WORLD FILM LOCATIONS SYDNEY

Edited by Neil Mitchell

T0345344

First Published in the UK in 2015 by Intellect Books, The Mill, Parnall Road, Fishponds, Bristol, BS16 3JG, UK

First Published in the USA in 2015 by Intellect Books, The University of Chicago Press, 1427 E. 60th Street, Chicago, IL 60637, USA

Copyright ©2015 Intellect Ltd

Cover photo: *Little Fish* (2005) ©Porchlight Films / Kobal Collection

Copy Editor: Emma Rhys

A Catalogue record for this book is available from the British Library

World Film Locations Series
ISSN: 2045-9009
eISSN: 2045-9017

World Film Locations Sydney
ISBN: 978-1-78320-362-8
ePDF ISBN: 978-1-78320-348-2

Printed and bound by Bell & Bain Limited, Glasgow

WORLD
FILM
LOCATIONS
SYDNEY

EDITOR
Neil Mitchell

SERIES EDITOR & DESIGN
Gabriel Solomons

CONTRIBUTORS
Anton Bitel
Gemma Blackwood
Dean Brandum
Martyn Conterio
Adrian Danks
Daniel Eisenberg
Lisa French
Alexandra Heller-Nicholas
Tina Kaufman
Jane Mills
Whitney Monaghan
Stephen Morgan
Erin Pearson
Jack Sargeant's
Deb Verhoeven
Sarah Ward

LOCATION MAPS
Greg Orrom-Swan

PUBLISHED BY
Intellect
The Mill, Parnall Road,
Fishponds, Bristol, BS16 3JG, UK
T: +44 (0) 117 9589910
F: +44 (0) 117 9589911
E: *info@intellectbooks.com*

Bookends. Sydney Harbour from Sydney Tower
(Photo by Ian Stchbens)
This page: *Lantana* (Kobal)
Overleaf: *33 Postcards* (Kobal)

CONTENTS

DEDICATION AND ACKNOWLEDGEMENTS

I would like to thank series editor Gabriel Solomons and all the staff at Intellect for their work behind the scenes on this and other projects. Special thanks go to all of the wonderful contributors who have made this book possible, their opinions, critical faculties, research skills and love of film has made this edition of *World Film Locations* a pleasure to edit. Many thanks are also due to the excellent location photography supplied by Shannon and Caitlin Neeson, Kate Cheater, Sam McCosh and Andrew Buckle – your efforts in getting around a city the size of Sydney are much appreciated. Once again, the support and encouragement of my family and friends has been invaluable.

NEIL MITCHELL

INTRODUCTION

World Film Locations Sydney

THE *WORLD FILM LOCATIONS* SERIES aims to highlight the importance of location to narrative in film, which we attempt to showcase through the interplay between image and text. This visually led series foregrounds physical environments, specifically locations in the great cities of our world, and the role they play in establishing, contradicting or strengthening the emotional spaces of the characters that inhabit them. Many of these locations, especially those off the tourist trail, are introduced to viewers for the first time on the big screen, instantly creating an impression of 'the city' in question formed through the use of genre, narrative drive and existing reputations employed by the film-makers.

This edition of the series, like the others, makes no claims to be comprehensive or definitive but, instead, seeks to open up the avenues of debate as to how film reflects and further enhances how we think about life in an urban environment. Through 46 short individual scene analyses from 46 individual films, complemented by half a dozen themed essays, our contributors, drawn from the worlds of academia, journalism and film criticism, offer up their views on the differing representations of Sydney on the big screen.

While a number of other cities are more commonly ascribed as major players in the history of cinema, Sydney, the largest and most populous city in Australia, has been regularly represented on-screen since the advent of the medium. Founded in 1788 by Captain Arthur Phillip, the first Governor of New South Wales, as a penal colony, Sydney has gone on to become the financial capital of the country and regularly features in the world's top-ten ranked cities in terms of 'liveability'. The cosmopolitan population, known as Sydneysiders, enjoys the world's second highest earnings based on domestic purchasing power and the city hosted the 1938 Commonwealth Games (then called the British Empire Games), the 2000 summer Olympics and the 2003 Rugby World Cup.

Sydney's diverse geographical make-up has always been a gift for film-makers both domestic and international. The site of two of the world's most iconic architectural landmarks – the Harbour Bridge and the Opera House – in a region believed to have been populated by indigenous Australians for some 30,000 years, the city also boasts over 100 beaches along its Pacific Ocean coastline and is studded with harbours, bays and rivers. Its modern CBD, inner and outer suburbs, industrial areas, plentiful parkland spaces and eclectic architecture have all played integral parts in reflecting fictional visions of Sydney. Whether the films involve alienated teens, immigrant communities, displaced Aboriginals, high-flying businessmen or blue-collar workers, Sydney has, across its near 5,000 square mile area, the environments and symbolic locations to suit them all.

Described by journalist and author Arthur Henry Adams as the 'Athens of Australia' and the 'Siren City of the South', Sydney attracts roughly 1 million visitors per annum, all of whom, in some way or other, will have had their view of the city enhanced, challenged or established by the films in which the city and its residents feature. ✢

Neil Mitchell, Editor

SYDNEY

City of the Imagination

Text by
TINA
KAUFMAN

SYDNEY IS A BEAUTIFUL CITY, perhaps too lovely; it's been called a city upstaged by its natural beauty. With its wonderful deepwater harbour, its string of ocean and harbour beaches within easy distance, its balmy and temperate climate, its iconic bridge and of course its Opera House, it offers much to both immediately attract the eye, and to give continuing pleasure. It's a city that breathes through a system of beautiful urban parks and gardens, many established in early colonial days. While it has a modern, upward-reaching city centre, many suburbs still congregate cosily around the bays and inlets of the harbour, and untouched bushland flourishes on headlands and in coves, as well as on the islands that dot the water.

Ferries, large and small, both old wooden ones and the more modern, high-powered craft, traverse the harbour. Huge cruise ships visit regularly, yachts of various shapes and sizes race, not only on weekends but on weekday evenings. Water traffic, from tugs and patrol boats to harbour cruise boats and water taxis, keeps the harbour busy and alive.

It's a city mainly built on sandstone, which is soft enough to tunnel through, but was hard enough for builders from colonial times onwards to use for the infrastructure of the emerging city, the bridges and walls and railway stations which still remain. Many government buildings, as well as the Sydney Town Hall, the Art Gallery, the State Library and the Australian Museum, are built of this sandstone, as are many churches and schools and early banks. It's a lovely mellow stone, giving much of the city a glowing warmth.

Sydney's Botanic Gardens, next to the Opera House, are a reconstituted version of nature established back in the time of Governor Macquarie. As part of the city, the Gardens give city workers as well as tourists a place to wander freely, to explore and to dream. The primary importance of the Gardens is scientific and botanical, but to many they are a wondrous, almost sacred space.

With all this beauty, these almost cinematic settings, you'd expect that the city would be much filmed. But strangely it's not the cityscape, the harbour or the beach that features most in Sydney-based films. Even the iconic Opera House, turning 40 this year and beloved of Australian artists, is a relatively infrequent location, although it is where the finale of the wonderfully exuberant musical, *Starstruck* (Gillian Armstrong, 1982) takes place. No, it's the suburbs, that sprawling mass of red-roofed houses, bleak industrial areas and busy shopping centres, of playing fields and often-deserted streets that have captivated and intrigued many local film-makers.

From the empty featureless streets around Bankstown in *The F.J. Holden* (Michael Thornhill, 1977) to the shabbily gentrified Glebe terrace houses of *The Last Days of Chez Nous* (Gillian Armstrong, 1992); from the strange night-time activities in posh Eastern Suburbs gardens in *The Night the Prowler* (Jim Sharman, 1979) to the bland, anonymous back lanes of *Idiot Box* (David Caesar, 1996); from the suburban strangeness of *Lantana* (Ray Lawrence, 2001) and the menace of *The Boys* (Rowan Woods, 1998) to the picturesquely bleak bayside locations in *Fast Talking* (Ken Cameron, 1984), where market gardens, windy beaches and industrial waste ground oddly co-exist; and from the disreputable, seamy night-time

Above © 2008 Australian Film Commission
Opposite © 1974 Hedon Productions

attractions of Kings Cross and Darlinghurst in *Two Hands* (Gregor Jordan, 1999), *Going Down* (Haydn Keenan, 1983) and *Candy Regentag* (James Ricketson, 1989) to the hot sunny days in the streets of outer suburbia in *The Black Balloon* (Elissa Down, 2008) (those same streets that seem so strange and alienating in *A Floating Life* [Clara Law, 1996]); it's there that film-makers have delved deep into Sydney's multifaceted life, while mainly ignoring the glamour and beauty of the city.

This focus on the suburbs started early; it can be seen in Australia's classic silent films. The tough working-class suburb of Woolloomooloo was vibrantly portrayed in Raymond Longford's *The Sentimental Bloke* (1919), in Lawson Harris's *Sunshine Sally* (1922) and in Tal Ordell's *The Kid Stakes* (1927). Longford, in fact, encouraged his actors to spend time in what was then the teeming inner-city area of Woolloomooloo, to familiarize themselves with the life of the community. *The Kid Stakes*, which manages to demonstrate just how ebullient a film without sound can be, with its hordes of exuberant children and its goat derby, sets up a contrast in the suburbs, with the working-class kids hunting for their missing goat in the elegant gardens of Potts Point mansions. But these working-class suburbs, Woolloomooloo and The Rocks, Darlinghurst, Newtown and Pyrmont, have now become gentrified, upmarket, as the demand for harbour views and inner-city

> **It's the suburbs, that sprawling mass of red-roofed houses, bleak industrial areas and busy shopping centres, of playing fields and often-deserted streets that have captivated and intrigued many local film-makers.**

locations grows; the battles fought in *Heatwave* (Phillip Noyce, 1982) and *The Killing of Angel Street* (Donald Crombie, 1981) between long-time residents and developers have largely been lost as Sydney's property boom continues unabated.

Of course, Sydney's beaches couldn't be kept out of local films, although they often appear through a fleeting memory or a short visit; The Bloke (Arthur Tauchert) and Doreen (Lottie Lyell) take a ferry to share a romantic visit to Manly Beach in *The Sentimental Bloke*, Sally is rescued from the surf at Coogee in *Sunshine Sally*, while a flashback to his girlfriend splashing in the Bondi surf briefly interrupts John Grant's outback nightmare in *Wake in Fright* (Ted Kotcheff, 1971). The two outlying beaches, Cronulla in the south, and Palm Beach in the north, have made distinctive appearances, with Cronulla's sandhills and deeply sexist surfing culture appearing in *Puberty Blues* (Bruce Beresford, 1981), and its sandhills standing in for the Sinai desert in World War I in Charles Chauvel's *Forty Thousand Horsemen* (1940). The glamorous, lushly upmarket Palm Beach appears strangely seedy in Albie Thoms's film of the same name (1980), which eschews the high life for the criminal pursuits of its disreputable characters. A more affectionate, contemplative portrait of Palm Beach is to be found in Bob Ellis's engagingly romantic, low-budget two-hander, *Unfinished Business* (1986).

Sydney is a city in which film plays a major role. While film production takes place all around Australia, a very large part of it is generated from and financed in Sydney. The city's long history of film-making has seen the development of a strong infrastructure of film studios, equipment and industry skills. The city has a strong and diverse film culture, and is home to the national film and TV school and to the federal government's funding body, Screen Australia. All these attributes saw Sydney being awarded the prestigious title of international 'City of Film' by the cultural arm of the United Nations, UNESCO, in 2010. Only the second city to be bestowed such a title, following Bradford in Northern England, Sydney has become a member of UNESCO'S Creative Cities Network, which includes Berlin, Montreal, Dublin, Seville and Melbourne (named as a City of Literature), and which was launched in 2004 to promote the social, economic and cultural development of cities. While Sydney's strength as a film hub has now been recognized, what it means to be a City of Film, however, is somewhat more mysterious. ✦

THE MAN FROM ENGLAND

Brian Trenchard-Smith in Sydney

Text by
ALEXANDRA
HELLER-
NICHOLAS

AS VIEWERS OF *Walkabout* (Nicolas Roeg, 1971) and *Wake in Fright* (Ted Kotcheff, 1971) can attest, there is a particularly rich vision of Australia afforded to film-makers who come to the country with fresh, foreign eyes. Few would debate Brian Trenchard-Smith's place as the King of Ozploitation cinema, shared perhaps only with Antony I. Ginnane. Both Ginnane and Trenchard-Smith understood from early on in their careers the importance of a global audience to Australian film-making – Ginnane has often quipped that his middle initial stands for "International' – and it is arguably Trenchard-Smith's British heritage that has afforded him such a lush vision of Australia, with a particular eye towards its relationship with genre film.

Although his loosely-defined shockumentary *The Love Epidemic* (1975) about sexually transmitted diseases included footage of the Sydney streets, it is his debut feature *The Man from Hong Kong* (1975) that most memorably associated Trenchard-Smith's Australian genre output with

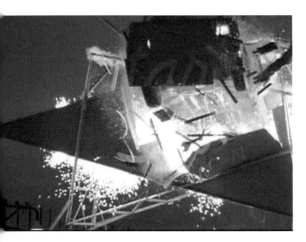

the city – one need only recall the iconic image of Jimmy Wang Yu karate-chopping legendary Australian stuntman (and Trenchard-Smith regular) Grant Page on the steps of the Sydney Opera House, an image that was used heavily to promote Mark Hartley's documentary *Not Quite Hollywood: The Wild, Untold Story of Ozploitation!* (2008). Aside from its significant role as the first Australian-Asian film production, it also was the second feature film for Academy Award winning cinematographer Russel Boyd, who would go on to become known for his work with fellow Australian film-maker Peter Weir in particular. The plot of *The Man from Hong Kong* is satisfyingly loose and wild, inspired as much by Asian martial arts films as it was by James Bond (the latter flagged overtly by the casting of a moustachioed George Lazenby as the film's villain). Trenchard-Smith wears his travelogue intent on his sleeve from the film's opening moments as he shows helicopters zooming over Uluru, but it is Sydney that captures the bulk of his attention. The high-octane kung fu action stops only for brief moments of lovemaking and hang gliding in a film riddled with shots of the Opera House and the Harbour Bridge.

Trenchard-Smith would give Grant Page a more central role in the joyfully ludicrous *Deathcheaters* (1976), a film that formed part of a canon of stunt men feature films of this period such as *EvelKnievel* (Marvin J. Chomsky, 1971), *The Stunt Man* (1980), *Hooper* (Hal Needham, 1978, and Trenchard-Smith and Page's later collaboration, *Stunt Rock* (1980). Following Page's character Rodney Cann and his colleague Steve Hall (played by John Hargreaves, who would go on to further Ozploitation acclaim in Colin Eggleston's 1978 film *Long Weekend*), aerial and street shots of Sydney abound in the freely strung together stunt-action vignettes that construct the film's gleefully wobbly

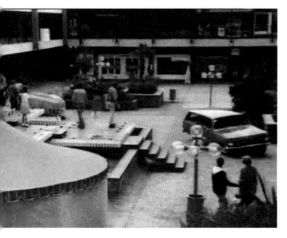

plot. One scene in particular uses the Warringah Mall in the Northern Beaches suburb of Brookvale – this is a notable location for Trenchard-Smith fans, as he would return to it seven years later to film key scenes in his most well-known film, *BMX Bandits* (1983).

This kids adventure movie about the bike-riding, walkie-talkie abusing, crime-fighting hijinks of three young teens is today known primarily for its crucial role in launching the career of Australian superstar Nicole Kidman. But *BMX Bandits* at the time provided what was even by Trenchard-Smith's unabashed standards his most brazen showcase for Sydney. Filmed predominantly around the Northern Beaches, the suburb of Manly is particularly privileged – a scene at the Manly Waterworks waterpark where the kids go down a slide on their bikes is one of the film's most memorable moments, and of course the Manly Oval and Manly Beach itself are also featured. One of the more curious location inclusions is a lengthy scene in the Manly Cemetery, where the teens are chased by mask-wearing criminals, revealing a noticeably different vision of Sydney than the beach-and-sunshine cliché that constructs the rest of the film.

Trenchard-Smith's creative use of Sydney locations peaks in *Dead End Drive-In* (1986). Filmed almost solely at the then-recently closed Star Drive-in in

Matraville, this *Mad Max* inspired film is based loosely on Peter Carey's 1974 short story 'Crabs'. In a dystopian not-to-distant-future, teenage hoodlums are confined in a drive-in that effectively acts as a concentration camp, imprisoning its inmates and condemning them to a life of trash film, bad drugs, local New Wave music, and all the neon you can eat. Viewing the film today, the drive-in itself evokes a nostalgia for an experience now sadly relegated to the past, and *Dead End Drive-In* is from this perspective a relic of this once-crucial site of social and cinematic engagement in suburban Sydney. This romantic vision of the Star Drive-in certainly was not active at the time of the film's making, however – although running from 1958 to-1984, the venue was incapable of turning a profit, and rumour has it that only nine cars attended its final night screening

Turning to horror, *Out of the Body* (1988) saw Trenchard-Smith turn his attention to yet another vision of Sydney. While treading on fairly standard supernatural terrain in this tale of astral travel, the first few moments of the movie locate it as a uniquely Sydney-based one, with its shimmering shots of the Opera House in silhouette, the glimmering lights of the harbour bridge and the city's recognisable evening skyline. The film's 'Sydney-ness' is flagged too by obvious markers such as a close up of the *Daily Mirror* tabloid, but *Out of the Body*'s most interesting choice of location would be its use of the University of Sydney campus, particularly its quadrangle (although its famous jacaranda tree was sadly out of bloom while the film was shot), with close-ups of the gargoyles that sit upon the university's library punctuating the movie at significant points.

Trenchard-Smith's legacy today is as much for his international genre work as it is his local productions: *Leprechaun 3* (1995) is set in Las Vegas, and the unfairly disparaged *Leprechaun 4: In Space* (1997) – as the title suggests – takes Trenchard-Smith's vision well beyond that of the Warringah Mall But he has certainly not turned his back on Australian locations, as testified by the Perth-based martial arts films *Day of the Panther* (1987) and *Strike of the Panther* (1987), and more recently in the disaster film *Actic Blast* (2010), set in Tasmania. It is Trenchard-Smith's Sydney-based Ozploitation films of the 1970s and 1980s, however, which remain his most famous, his most playfu, and his most distinctly Australian works. ✢

It is Trenchard-Smith's Sydney-based Ozploitation films of the 1970s and 1980s, which remain his most famous, his most playful and his most distinctly Australian works.

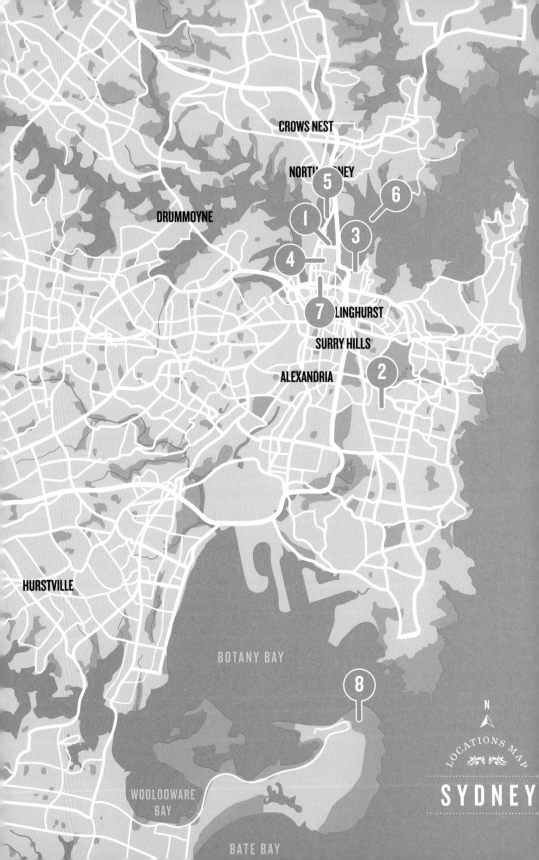

CROWS NEST

NORTH SYDNEY

DRUMMOYNE

5

6

1

3

4

7 LINGHURST

SURRY HILLS

2

ALEXANDRIA

HURSTVILLE

BOTANY BAY

8

N

WOOLOOWARE
BAY

LOCATIONS MAP

SYDNEY

BATE BAY

SYDNEY LOCATIONS

SCENES 1-8

maps are only to be taken as approximates

THE SENTIMENTAL BLOKE (1919)

LOCATION *Sydney to Manly ferry*

BASED ON C.J. DENNIS'S popular verse, *The Sentimental Bloke* is a simple tale of romance between a ne'er-do-well named Bill (Arthur Tauchert) and his 'ideel tart' Doreen (Lottie Lyell). Dennis's original focused on the larrikin elements of Melbourne's notorious Little Lon district, but the film transposes the action onto the equally disreputable inner-Sydney neighbourhood of Woolloomooloo. The film brings more than a hint of realism to its portrayal of a working-class milieu, aided in no small part by vernacular, first-person intertitles and the ample use of Woolloomooloo street locations. Several key moments take place in more liberating spaces of urban escape, however, allowing the characters to break free from the physical and psychological confinement of their daily lives. Thus, when Bill needs space to think about his future, he goes to the Botanic Gardens. Similarly, the couple's first date is a moonlit escape from the cramped confines of the 'Loo to the Northern Beaches, sharing chocolate on that most iconic of Australian transport links, the Sydney to Manly ferry. Harbour transport has featured extensively in Australian cinema ever since 1896, when Lumière agent Marius Sestier (and local partner Henry Barnett) recorded Australia's first motion picture as passengers alighted from a ferry at Manly. Following the ferry ride, Bill and Doreen share their first romantic entanglement on the equally iconic Manly Beach, as crowds mill on the promenade, the heads surrounding neighbouring Queenscliff Bay rising in the background. ➡️***Stephen Morgan***

Photo © www.manlyaustralia.com.au

Directed by Raymond Longford
Scene description: Ferry to Manly and a moonlit beach encounter
Timecode for scene: 0:23:12 – 0:28:30

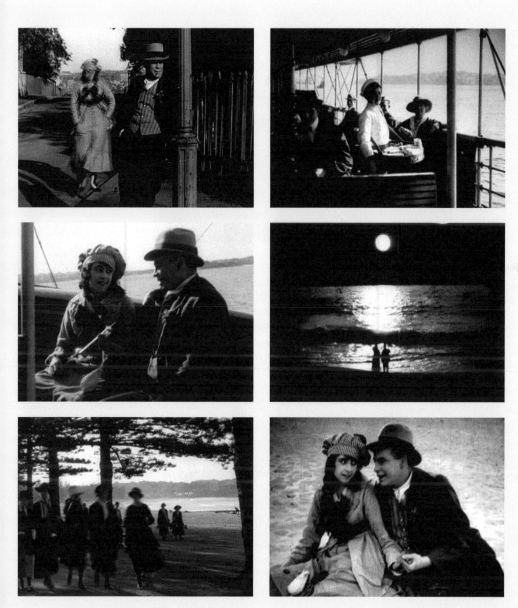

Images © 1919 Southern Cross Feature Film Company

SILKS & SADDLES (1921)

LOCATION *Royal Randwick Racecourse, 77–97 Alison Road, Randwick, NSW 2031*

THE AUSTRALIAN LOVE AFFAIR with sport, whether watching or participating, is embedded deep within the national psyche, something that is periodically reflected on the big screen. Horse racing is hugely popular and movies such as *Thoroughbred* (Ken G. Hall, 1936) and *Phar Lap* (Simon Wincer, 1983) have been set in the world of racing. Another of these is John K. Wells's silent movie *Silks & Saddles*, in which breeder's daughter Bobbie Morton (Brownie Vernon) rides Alert, the horse she has been gifted by an admirer, to victory in a big race. *Silks & Saddles* is one of only two surviving films to have been made at the Palmerston Studio in Waverley, with the 28-room former colonial mansion, now luxury apartments, providing the film's interiors. A romantic drama, both in terms of its representation of an underdog triumph and Bobbie's personal life, the film heavily features Sydney's Royal Randwick Racecourse as the other of its two main locations. Opened in 1833, and known as 'headquarters' to many local race fans, the racecourse in *Silks & Saddles* becomes a location where dreams are realized and underhand plans foiled. Forced to replace Alert's jockey, who is caught up in a ploy to stop the horse winning, Bobbie takes the reigns herself. Though the race ends in a dead heat, the rival jockey, part of the nefarious plan, is disqualified for being under the required weight. Being crowned the winner sees Bobbie fulfil an ambition, while the financially motivated plans of her enemies are ruined in the process. **↝ Neil Mitchell**

Photo © Shannon & Caitlin Neeson

Directed by John K. Wells
Scene description: The big race
Timecode for scene: 1:08:03 – 1:12:43

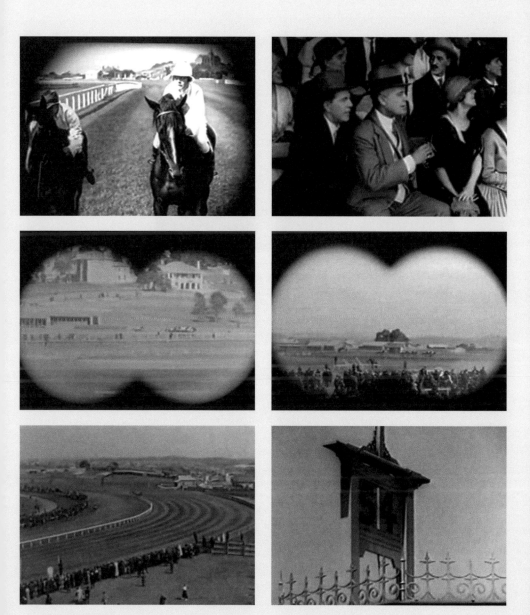

Images © 1921 Commonwealth Pictures

THE KID STAKES (1927)

LOCATION *Cowper Wharf Road, Woolloomoloo, NSW 2011*

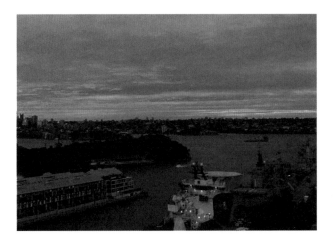

ADAPTED FROM SYD NICHOLLS'S newspaper comic strip, *Fatty Finn*, *The Kid Stakes* joined a loose cycle of silent era films shot on location in Woolloomooloo, a cramped, working-class district of inner Sydney wedged between the open expanses of the Royal Botanic Gardens and Domain, and the well-to-do suburb of Potts Point. Drawing on the Hollywood series *Our Gang* (1922-44) and mocking popular gangster films, *The Kid Stakes* tells the story of Fatty Finn (Robin 'Pop' Ordell) – so called, of course, because he was *not* fat – leader of a gang of local kids who dreams of life as a racing driver, but must settle for entering Hector, his pet goat, in the eponymous harness race. Early in the film, Fatty joins his gang as they play cricket in a vacant lot on Cowper Wharf Road, which curves around Woolloomooloo Bay, separating the residential and commercial district from the docks. Built in the 1860s, Cowper Wharf was a long, semi-circular timber wharf that curled around the bay, named in honour of local MP and New South Wales Premier Charles Cowper. During the modernisation of Sydney's harbour facilities in the 1910s, Cowper Wharf was bisected by a 410-metre long timber structure dubbed Finger Wharf, the south-western corner of which appears in the background of this scene. The new wharf mostly handled wool (as well as soldiers during wartime), but now houses a luxury hotel/apartment complex. The scene also reveals other dockside buildings, now long gone, as well as the unloading of ships and a tram on the line that linked Woolloomooloo to central Sydney between 1915 and 1935. **Stephen Morgan**

Photo © Panoramio

Directed by Tal Ordell
Scene description: A dockside cricket match
Timecode for scene: 0:08:53 – 0:13:37

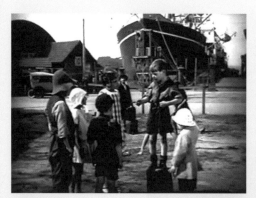
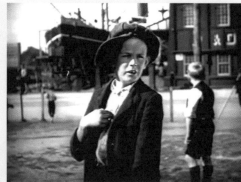
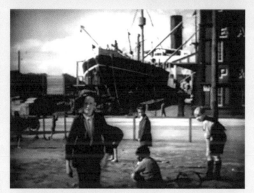
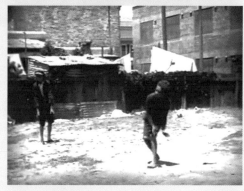

Images © 1927 Ordell-Coyle Productions

DAD AND DAVE COME TO TOWN (1938)

Cinesound studio, 65 Ebley Street, Bondi Junction, NSW 2022

KEN G. HALL was the largest producer of feature films in Australia during the 1930s and 1940s. *Dad and Dave Come to Town* is one of his most emblematic films, fusing together the rural "backblocks" sensibilities of the impresario's early-mid '30s movies such as *On Our Selection* (1932) and *The Squatter's Daughter* (1933) with the burgeoning sophistication and streamlined potential of his increasingly studio-bound work of the second half of the decade. Somewhat ironically, Hall's affectionately remembered opus stages the fish-out-of-water journey of the wildly popular Rudd family from rural NSW to the busy, modern streets of an unnamed Sydney, within the confines of Cinesound's Bondi Junction studio. Utilising the imported technologies of rear-projection and optical printing, and the space transforming capacities of the modern studio, the Rudd family's arrival in "town" is a riot of superimpositions, contrastive visual planes and geographies, overlapping cinematic and theatrical spaces. Introduced via an archway that frames a Sydney street, this "multi-location" sequence moves from the train station to the middle of a busy thoroughfare through the power of montage and superimposition, emphasising the discomfort and disorientation of the elder Rudd family as they encounter (for the first time in twenty years) the modernisation of the city and its transformation by transport, electricity, architecture, urban design and, ultimately, the cinema. The contrastive planes of the image suggest that these neophytes are out of place within the bustling but cinematically confected city, while attesting to the pre-eminence of Hall's Bondi studio as one of the most important locations in Australian cinema history. **⦁▸Adrian Danks**

Photo © Kate Cheater

Directed by Ken G. Hall

Scene description: 'pedestrian refugee'

Timecode for scene: 0:20:11 – 0:21:13

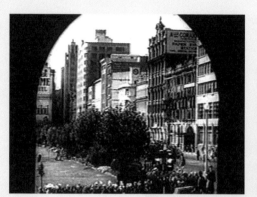
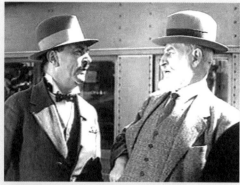
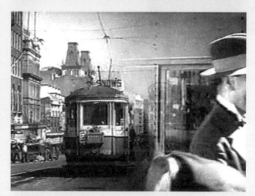

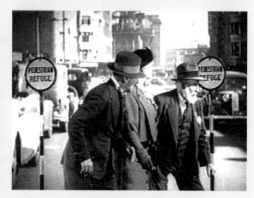

THREE IN ONE (1957)

LOCATION

Dawes Point, beneath the Sydney Harbour Bridge

THE SYDNEY HARBOUR BRIDGE is probably the only true urban icon of Australian cinema. It is used in numerous films such as John Farrow's *The Sea Chase* (1955) and Michael Powell's *They're a Weird Mob* (1966) to immediately establish the topography of Sydney and orientate viewers to a film's location. Cecil Holmes's *Three in One* was the only home-grown feature produced in 1957 and remains one of the most remarkable, ambitious and idiosyncratic films made before the 1970s revival. Divided into three distinct stories covering different locations, characters and moments in time, it focuses on questions of community, social responsibility and environment through the adaptation of stories by Henry Lawson, Frank Hardy and Ralph Peterson. The final episode of Holmes's socially engaged and openly leftist film, "The City", highlights the day-to-day struggles of a young couple labouring to earn enough money to get married. Although the Harbour Bridge is glimpsed more picturesquely and holistically in various shots earlier in the story, its sometimes foreboding presence in the couple's extended night-time tryst at Dawes Point is remarkable for its use of expressive low-key lighting, its evocative soundtrack, and the minimalism of its silhouetted and illuminated outlines of the overarching bridge and the distant Luna Park. Moving from a tracking shot of the couple looking suggestively and uncomfortably at a display window of double beds, the scene is an extended expression of sexual frustration staged beneath the Harbour Bridge and relying heavily on the kind of silhouetted imagery then and now familiar from film noir. ❧**Adrian Danks**

Photo © Shannon & Caitlin Neeson

Directed by Cecil Holmes
Scene description: 'lights always make things more beautiful than they are'
Timecode for scene: 1:07:35 – 1:12:43

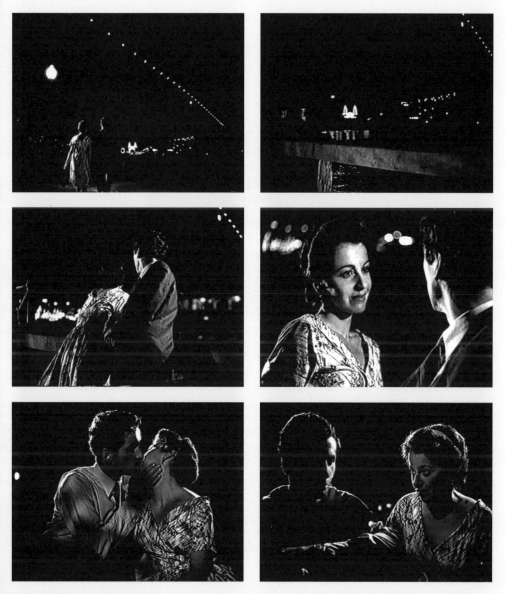

THE SIEGE OF PINCHGUT (1959)

LOCATION *Fort Denison (aka Pinchgut Island), Sydney Harbour, NSW 2000*

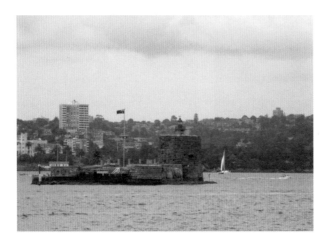

THE FIFTH AND FINAL FILM of Ealing Studios's Australian venture (and the last film bearing the logo of that prestigious British company), *The Siege of Pinchgut* is a contemporary urban thriller featuring American import Aldo Ray as Matt Kirk, a prison escapee desperate to clear his name. Attempting to flee Sydney Harbour undetected, Kirk and his accomplices find themselves stranded on Fort Denison (known colloquially as Pinchgut Island), where they hold the caretaker and his family hostage, and the city of Sydney to siege, training high calibre guns on a nearby naval freighter loaded with ammunition. Partly inspired by the devastating Bombay Explosion of 1944 which killed around 800 people, the film builds to a climax as Kirk attempts to carry out his threat to annihilate Sydney. Foiled by his younger brother Johnny (Neil McCallum), Kirk is determined not to return to jail, and climbs the tower, where he is shot by police and falls to his death. The film concludes with Johnny in police custody, returning to the society that his brother was so desperate to destroy. Deliberately commercial and lacking in Australian specificity, the film nevertheless makes good use of its Sydney locations, centring upon this small, fortified island adrift in Sydney harbour. A rocky outcrop known to the local Eora population as Mallee'wonya (and later dubbed Rock Island by Governor Philip), its sandstone was quarried to build Circular Quay, before fortification in the 1840s in an attempt to bolster the harbour's inner defences. Now a popular tourist attraction, Fort Denison houses a restaurant, function centre and museum. **•• *Stephen Morgan***

Photo © Shannon & Caitlin Neeson

Directed by Harry Watt
Scene description: Matt Kirk's last stand
Timecode for scene: 1:32:17 – 1:40:00

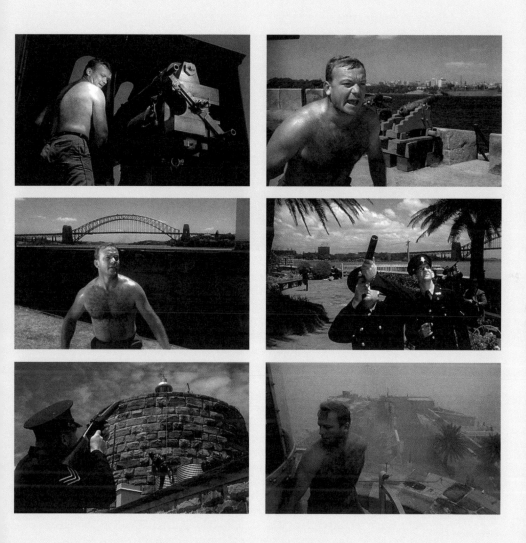

THEY'RE A WEIRD MOB (1966)

LOCATION

*Marble Bar, The Adams Hotel, Pitt Street, Sydney NSW 2000
(Relocated to the basement of the Hilton Hotel, George Street,
NSW 2000 in 1973)*

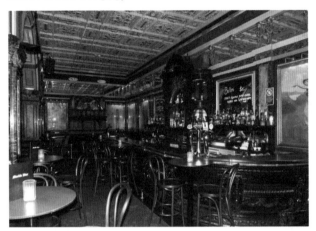

ITALIAN IMMIGRANT NINO (Walter Chiari) arrives in Sydney excited to be
writing for the magazine he co-owns with his cousin. His first day as a "New
Australian", however, is discouraging: his cousin has absconded owing money
to the lovely Kay (Claire Dunne) who appears immune to Nino's charms. A
dispirited Nino plunges into the Marble Bar on Pitt Street in Sydney's CBD
to find a haven of old-world nineteenth-Century European excess tapping
fifteenth-Century Italian Renaissance luxury. It's a kaleidoscope of 35
different coloured marble, stained glass windows, painted ceilings, ornate
mahogany carving, and startling artwork showing impressionist artist Julian
Ashton's (b.1851–d-1942) penchant for naked maidens. But non-Australian
directors and writers, Michael Powell and Emeric Pressburger, focus on the
rich language rather than the sumptuous surroundings. Nino has his first
lesson in that impenetrable language called "Strine" from an Aussie bloke
(Jack Allen) and Anne Haddy's barmaid, the sole sheila in the establishment.
Nino learns the difference between 'schooner' and 'middy' (425 ml and 285
ml beer glasses), to 'shout' when it's his turn to buy a round and to ask what a
mate does for a 'crust' when he wants to know his job. Based on the supposed
"autobiography" of 'Nino Culotta' – actually, Irish-Australian John O'Grady -
the film revels in humorous international misunderstandings. Later, when a
drunk tells some non-English speaking immigrants to "go back to your own
bloody country", it's the drunk who is out of place. This, of course, is the joke:
neatly collapsing the distinction between 'us' and 'them', the film could have
been called "We're a Weird Mob". **⇢Jane Mills**

Photo © Shannon & Caitlin Neeson

Directed by Michael Powell
Scene description: 'Your shout'
Timecode for scene: 0:30:04 – 0:31:03

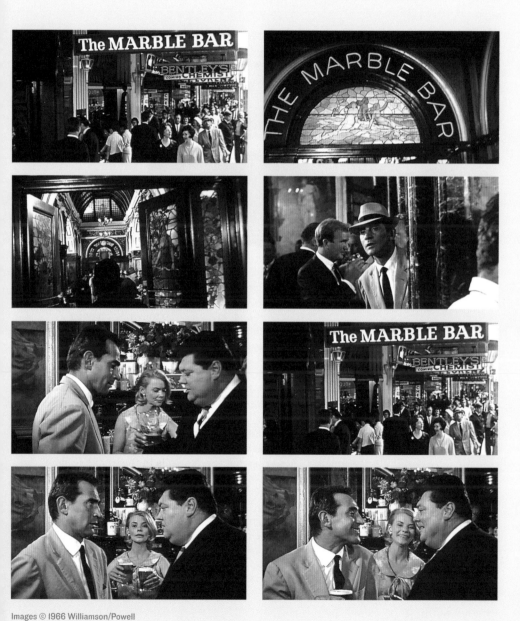

STONE (1972)

Captain Cook's Landing Place, Kurnell, NSW 2231

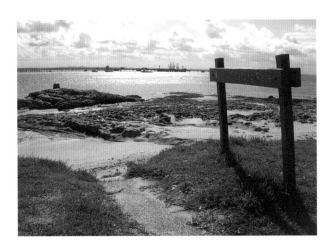

PERHAPS *THE* QUINTESSENTIAL Sydney set movie, due to its use of many iconic locations, Sandy Harbutt's *Stone* is a crime thriller with a political edge wrapped up in a biker movie. As rough and ready as The Grave Diggers motorcycle club the plot revolves around, *Stone* is less romanticized and a lot meaner than the sub-genre's most famous entry, *Easy Rider*. When a number of their members are murdered, The Grave Diggers allow Ken Shorter's undercover cop Stone to ride with them in the hope he can solve the crimes. Utilizing places frequented by actual motorcycle clubs, such as the now long since closed Forth & Clyde pub in Balmain, Harbutt's movie also employed the city's beaches, tourist attractions, outer suburbs, cemeteries, surrounding freeways and coastline fortifications. The film's opening, however, was shot at the very birthplace of Australia as we now know it, Captain Cook's Landing Place in Kurnell. A wordless pan and scan sequence lasting just over a minute, the opening scene may not involve any dialogue, or indeed any characters, but it symbolically speaks volumes. Moving from the memorial to Midshipman Isaac Smith, the first European to set foot in Eastern Australia, the camera eventually rests on a sign reading 'No Swimming, Extreme Pollution'. The political assassination that follows, witnessed by one of The Grave Diggers, drives the plot forward, but the opening scene deftly implies that if it wasn't for the colonisation that followed Cook's arrival, the country may have remained free of ecological damage and spiritual erosion.
➥Neil Mitchell

Photo © Panoramio

Directed by Sandy Harbutt
Scene description: Symbolism at Captain Cook's landing place
Timecode for scene: 0:00:00 – 0:01:13

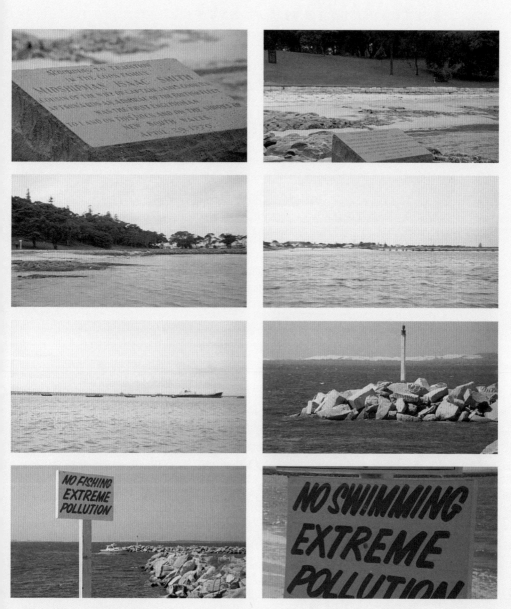

THE WORLD BEHIND THE COKE SIGN

Text by
JACK
SARGEANT

Jon Hewitt's Kings Cross

KIN'S CROSS HAS BEEN KNOWN as Sydney's red light district, and has been the home to strip joints and nightclubs since the 1920s. The most densely populated area in the country, with residents – from the inner city poor to young, single city workers and several generations of bohemians – living in small apartments and units rather than the large houses that inform the classic manifestation of the Australian Dream. Defined by deco apartments, tiny bedsits and what were once workman's houses, the Cross remains an utterly unique neighbourhood compared to much of the country

With its lengthy history of prostitution, sly-grog, razor gangs and various forms of crime, the Cross's reputation for all forms of entertainment and vice has only increased over the decades. The inner city suburb's, alleys and streets saw some of the first burlesque clubs, drag shows, jazz dives

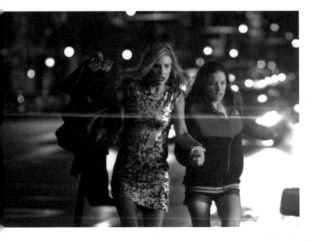

and brothels in Sydney, and the neighbourhood has long been considered insalubrious. By the early 1960s luridly packaged pulp paperbacks such as *Kin's Cross Affair*, *Vice Trap Kings Cross*, *Night In Kings* , and *The Kings Cross Racket* were hitting the newsstands, books published by an industry that understood the demand for a locally set exploitation literature. These books contributed to the popular cultural myth of Kings Cross, feeding the lascivious desires of both those moral-tongue-clickers who sought to censure the neighbourhood and those fascinated suburbanites and out-of-towners anxious to tread its soiled sidewalks hoping to find and sate their hedonistic kicks. Adding to the popular imagination of the era the television documentary film *The Glittering Mile* (1964) depicted the vagaries of life in the Cross, interviewing locals, notable personalities and bohemian figures as well as trawling the late night streets, documenting the night people and hoards of tourists

In recent years the contemporary Kings Cross has been essayed in two gritty, hardboiled feature films by Australian director Jon Hewitt: *darklovestory* (2006) and *X: Night of Vengeance* (2011 - known simply as *X* in Australia). Each of these films focuses on a relationship against the background of vice and crime in Kings Cross, *darklovestory*'s narrative follows a couple after a botched robbery and *X: Night of Vengeance* is concerned with two women involved in prostitution, both films touch on elements of crime and police corruption. The first two-thirds of a proposed Kings Cross trilogy, these films are deeply embedded within the neighbourhood in which Jon Hewitt and writing partner, actress

Above © 2006 Paper Bark Films Pty. Ltd., Rough Beast
Opposite © 2011 Circe Films, Rough Beast

Belinda McClory, lived during the creative and production processes.

The Kings Cross that appears in Hewitt's underground, low-budget feature *darklovestory* verges on the surreal, the neon lights form an abstracted experimental luminescence that plays around protagonists Gil (Aaron Pedersen) and Gretchen (Belinda McClory) as they walk, run and stumble through the inner city streets; The bursts of neon visual disturbance mirroring and contributing to the sense of desperation and psychological dislocation the protagonists face as the narrative slowly unwinds. The back alleys and side streets dominate the neighbourhood in *darklovestory*, further adding to the sense of loss, confusion and desperation. Here the streets of Kings Cross become a shifting, protean landscape, in which every turn leads to risk, and the brilliant neon refulgence of the streetlights lose their lustre, and shadows dance at the edge of the image.

In *X: Night of Vengeance*, Kings Cross appears as an even grittier and darker urban suburb. In contrast to the guerrilla style shooting that defined the production of *darklovestory*, *X: Night of Vengeance* was shot over twenty-nights in

the neighbourhood. The streets here are crowded with people spilling from clubs and fast food restaurants, emphasising the isolation of runaway Shay Ryan (Hanna Mangan Lawrence), separated from the world around her and drifting desperately through the Cross. In sharp contrast the high-class prostitute Holly Rowe (Viva Bianca) sees the streets through car windows, removed from the actions on the street through her money and experience

The action in *X: Night of Vengeance* takes the audience off of the streets and into the clubs and hotels that define the infamous golden mile of Kings Cross. When Shay is being chased and runs through a club the crew shot the film in the actual space – director, cameraman and actress running through the building and completing the shot in one-take. Later in the film, as the protagonists walk through a strip club, a real bar was used, with several of the club's dancers and performers appearing in the film. Similarly, the scenes shot in hotel rooms were filmed in the neighbourhood. While the film's narrative may have been fictional, the locations are all authentic, offering the audience a naturalistic depiction of the Kings Cross that exists behind the well-lit street facades.

Both *darklovestory* and *X: Night of Vengeance* exist in the night world of Kings Cross. The narratives of both capture the rapid staccato of life in the area with the entire action of each transpiring over a single night. These are films in which the night functions not merely as a temporal framework for the action, but as the space in which the inner city neighbourhood is born anew. If the dawn heralds a new day to most, then in the Cross it is the dusk that is the harbinger for night side possibilities. These two movies exist as urban cinematic nocturnes; these are films that call forth a world of neon-etched darkness, dirty back streets and all manner of night people.

While the Cross has inspired other film-makers – such as Philip Noyce who directed the drama *Heatwave* (1982) that similarly explored the underbelly of the neighbourhood – and fittingly featured in the likes of junkie drama *Candy* (Neil Armfield, 2006) and gangster black comedy *Two Hands* (Gregor Jordan, 1999), Hewitt is unique in the tenebrous poetry he has carved from these streets. While some may have seen the ongoing gentrification of inner city suburbs slowly encroaching on Kings Cross, Hewitt's films remain a testament to the greasy, sexy, criminal, sweaty and dangerous edge to the neighbourhood and the dark side poetry it can still inspire. ✚

Both *darklovestory* and *X* exist in the night world of Kings Cross. The narratives of both capture the rapid staccato of life in the area with the entire action of each transpiring over a single night.

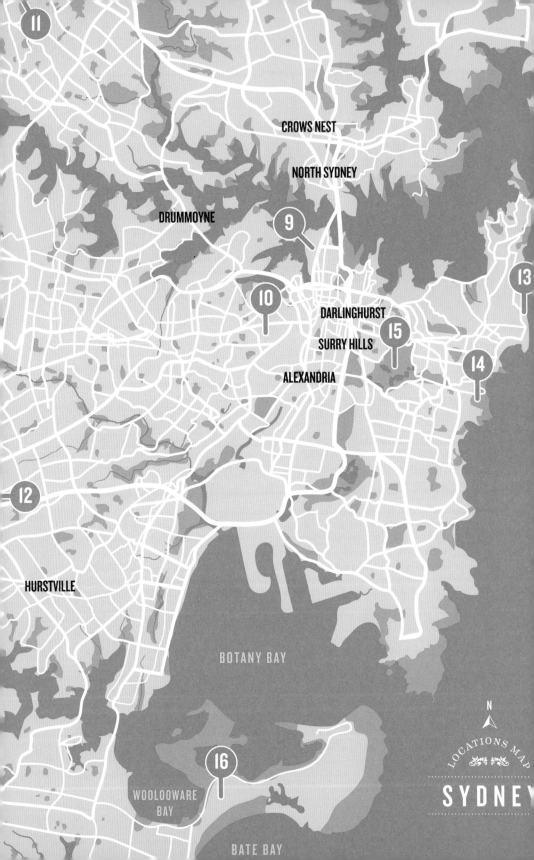

CROWS NEST

NORTH SYDNEY

DRUMMOYNE

9

10

DARLINGHURST

SURRY HILLS

15

ALEXANDRIA

13

14

11

12

HURSTVILLE

BOTANY BAY

16

WOOLOOWARE
BAY

BATE BAY

N

LOCATIONS MAP

SYDNEY

SYDNEY LOCATIONS

SCENES 9-16

maps are only to be taken as approximates

THE MAN FROM HONG KONG (1975)

LOCATION *Esso House, 127 Kent Street, Millers Point, NSW 2000*

WHEN NARCOTICS AGENTS intercept a drug deal at Uluru and apprehend a Hong Kong national they call upon Inspector Fang Sing Leng (Jimmy Wang Yu) of the Hong Kong police to come to Sydney to assist with their efforts to identify the local intended source of the shipment. Utilising a combination of detection skills and brutal Kung Fu, the inspector traces the shipment to local kingpin Jack Wilton (George Lazenby), who is ruthless in protecting his criminal empire. With both men expert in martial arts and equally determined, a violent final confrontation is promised. The site used for Wilton's heavily fortified penthouse lair is the former Esso House at Millers Point. It is here where the film climaxes, as Fang bypasses security by hang-gliding onto the roof, abseiling down the side and crashing through the window. The ensuing brutal fight crescendos with an explosion that rips through the penthouse, the flames and smoke visible across the city skyline. The Millers Point location and Fang's rooftop exploits allow for panoramic views of 1970s Sydney and its harbour with the then modern building complex emphasising Wilton's position of influence. As the final credits roll, a wide shot of his fiery downfall can be seen by all in the city he once controlled A part of the Sydney skyline until 1992, the ESSO House was eventually demolished to make way for the Highgate apartments, a 28-storey skyscraper offering luxury residencies, a concierge, indoor pool, library, spa and gym.
➥ Dean Brandum

Directed by Brian Trenchard-Smith
Scene description: An explosive climax
Timecode for scene: 1:29:00 – 1:40:00

CADDIE (1976)

Royal Prince Alfred Hospital, 50 Missenden Road, Camperdown, NSW 2050

BASED ON A SEMI-FICTIONALISED MEMOIR, *Caddie* tells the story of a young mother in the 1920s who, leaving her violent husband, finds herself homeless and penniless. Caddie (Helen Morse) works as a barmaid in a rough pub where a smooth-talking admirer (a dashing Jack Thompson) names her after his Cadillac because she's sleek and classy. She and her friend (an incandescent Jacki Weaver) suffer the nightly "six o'clock swill" when, desperate for one more drink before closing time, men vomit, pass out and piss at the bar. The poor, working class women are depicted with fine regard for the brutal truth: their back street abortions and dependency upon often uncaring men are underlined by the real locations and beautifully recreated sets. Caddie's resilience nearly cracks when her young daughter almost dies from diphtheria. In a beautifully filmed scene in the children's hospital, a fearful Caddie and her son sit all alone in the sepulchral, autumnal tones of the waiting room (now a busy hallway). To the non-diegetic sound of Peter Flynn's sad piano music, a back-lit stained glass window depicting Christ as "caritas" offers little hope. But then a nurse brings a cup of tea: the little girl has survived. Back home, Caddie cries tears of relief. Producer Anthony Buckley's decision to film in 45 locations in 36 days was worth it. The production team so obviously cared about time and place that seeing Donald Crombie's film is like taking a virtual stroll through depression era Sydney. The clothes, hairstyles, sets and, above all, the locations are perfect.
➻ Jane Mills

Photo © Shannon & Caitlin Neeson

Directed by Donald Crombie
Scene description: 'Your little girl is dying'
Timecode for scene: 0:30:04 – 0:31:03

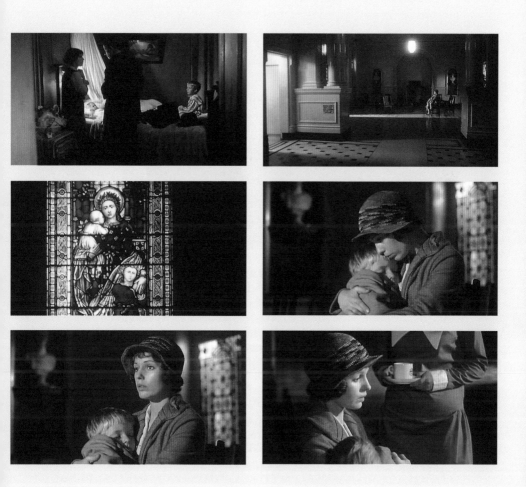

DON'S PARTY (1976)

BASED ON DAVID WILLIAMSON'S PLAY of the same title, *Don's Party* is a satirical comedy about the hope and disappointments of middle-class Australia. Set before a backdrop of federal politics, the film takes place in the Sydney suburb of Westleigh on election night, 1969. Suburban couple Don and Kath Henderson (John Hargeaves and Jeanie Drynan) host a party to celebrate an expected Labor victory after twenty years of Conservative government. Permeated with hope, the film begins with the Henderson family driving to the polling station. A bright "Swing to Labor" sticker on their car window is foregrounded as they drive through conservative suburbs – they pass house after house with "Vote Liberal" placards in the front garden. After successfully voting, they return to their home in Windham Place, Westleigh, and the debaucherous party at the heart of the film begins. It is not long before the tone of Bruce Beresford's film shifts from hope to disappointment and this is exacerbated by the results of the election emerging on the television in the centre of the home. In this quiet, leafy street in Westleigh, the men begin to drink with reckless abandon and attempt to seduce each other's wives, while the wives and girlfriends complain about their own bitter disappointments – aptly summed up in their conversations about their respective partners. •• ***Whitney Monaghan***

Photo © Google street view

Directed by Bruce Beresford
Scene description: Before the party
Timecode for scene: 0:00:00 – 0:05:25

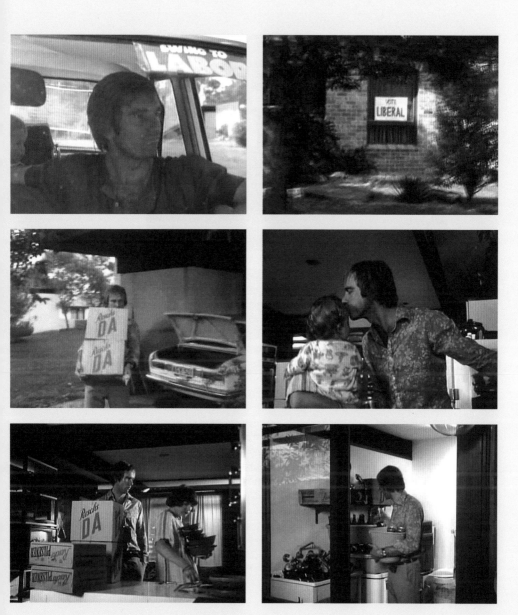

THE F.J. HOLDEN (1977)

LOCATION *Food Court of the Bankstown Central Shopping Centre, Bankstown, NSW 2200*

KEVIN (PAUL COUZENS) works in a car wrecker's yard and spends most of his time with his friend Bob (Carl Stever). When not working on restoring Kevin's classic F.J. Holden they are aimlessly cruising the streets of Bankstown. Kevin becomes friendly with Anne (Eva Dickinson) and soon a relationship begins between them as both take their uncertain steps into adulthood. Like its characters, Michael Thornhill's bleak drama seldom strays from the Bankstown streets, with the one foray to a snooty establishment in neighbouring Milperra resulting in an uncomfortable date for Kevin and Anne. A great deal of *The F.J. Holden* presents the characters driving and depicted with a near circular direction as if unable or unwilling to leave the area. Composed with a realist aesthetic, the film acts as a valuable visual record of the suburbs at the time, with key sequences set within the Bankstown Square (as it was then known) shopping mall. Here is where Eva works in a clothing store and early in the film she meets with two friends for lunch in the food court. They dine at the World Fare Restaurant and the camera lingers with interest on the Asian food being prepared. When seated the girls discuss cars and sex acts, conversations not dissimilar from those shared between the men of the film. Their social outlets restricted, education limited and prospects pre-ordained, it appears that for all the characters of *The F.J. Holden*, experiences of the world outside Bankstown will not extend past what's found at the World Fare. ◦**Dean Brandum**

Photo © TCL 1961 (Flickr)

Directed by Michael Thornhill
Scene description: The girls do lunch
Timecode for scene: 0:07:55 – 0:10:45

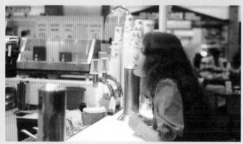 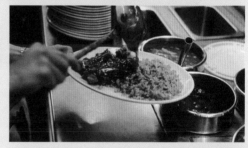

 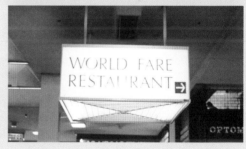

THE LAST WAVE (1977)

Bondi Sewage Treatment Works, North Bondi, NSW 2026

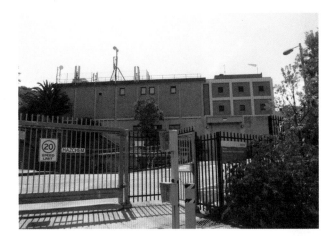

THE LIFE OF LAWYER DAVID BURTON (Richard Chamberlain) is turned upside down when he acts as legal defence for a group of Indigenous men accused of murdering another man under tribal law. Aside from struggling with the official government denial of tribal law as a legitimate defence, David also has increasingly disturbing visions and develops a strange connection with one of the defendants. As he learns to accept non-western ways of thinking, the film's climax hinges upon David's role in the apocalyptic flood of the film's title. At the heart of *The Last Wave* lies white Australia's inability to comprehend the meaning of the rain, and the film exposes the impotence of western rationality in the face of a belief system it has systematically denied. It spectacularly explores the failures of Eurocentric reason in understanding certain phenomena. With tribal activity forced underground into the tunnels of the Bondi Sewage Treatment Works, the ugliness of European Australian assumptions that link Indigenous Australia to the abject is made tangible. Simultaneously, however, David's increasingly leaking house suggests that the lines distinguishing the so-called 'civilized' and 'primitive' are themselves extremely fragile. It is in these tunnels that the accused Chris (David Gulpilil) finds his victim guilty of stealing sacred objects, leading to the murder at the centre of the film's plot. Rather than rendering its Indigenous characters and their associated apocalyptic portents as monstrous, however, in *The Last Wave* they personify a legitimate spiritual alternative to western modernity.
↝ Alexandra Heller-Nicholas

Photo © Shannon & Caitlin Neeson

NEWSFRONT (1978)

Waverley Cemetery, St Thomas Street, Bronte NSW 2024

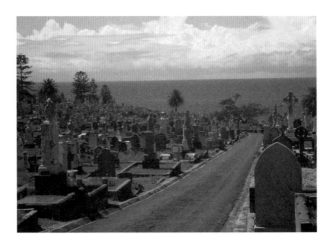

IN THE 1970S, writer/director Phillip Noyce and his co-scribe Bob Ellis looked back on the traditions of cinema from decades earlier, specifically the screening of newsreels with features. Their film, *Newsfront*, told of the changing of the political and cultural landscape, with the plights of two brothers – the older, cautious Len Maguire (Bill Hunter) and the younger, excited Frank (Gerard Kennedy) – unfurled in tandem. From 1948 to 1956, their personal and professional exploits are plotted against historic events, chapter-like segments charting elections, referendums, disasters and the coming of television. Len stays in Australia, following the sensible, modest path. Frank departs for America, seeking difference and embracing new experiences. Both are immersed in an industry evolving beyond their expectations. In a brief pair of scenes, the moment of change dawns upon the Maguire brothers, altering the tone of a spirited afternoon. At Len's house backing on to the Waverley Cemetery, family and friends gather to help build an addition to his new home, with his first child an imminent arrival. Bad weather forces the party inside, and when the merriment subsides the siblings depart for a walk and a swim. Drifting through tombstones, Frank reveals his plans to move to America, much to Len's surprise; the monuments tower over their forms as they chat, their shadows long and their symbolism obvious. In the famed Sydney locale, first Noyce equates the safe choice, staying, with the ultimate end and then he weakens a bond of 33 years amongst rows of fading, crumbling memorials. **◄◄Sarah Ward**

Photo © Kate Cheater

Directed by Phillip Noyce
Scene description: A barbeque turns into a walk and swim
Timecode for scene: 0:28:18 – 0:33:04

THE NIGHT THE PROWLER (1978)

LOCATION *Centennial Park, NSW 2021*

JIM SHARMAN'S *The Night the Prowler*, adapted from his own short story by acclaimed novelist and playwright Patrick White, is a scabrous satire on the various insecurities, neuroses and existential crises that cripple the privileged, but dysfunctional, Bannister family in the city's Eastern Suburbs. The repressed central character, Felicity (Kerry Walker), daughter to an overbearing mother, Doris (Ruth Cracknell), and a distant father, Humphrey (John Frawley) is as much of a misfit in her comfortable, but suffocating, family home in Centennial Park as the film itself is in the body of Australian cinema. Shot through with absurdist humour, bizarre flights of fancy and moments of horror, *The Night the Prowler* aesthetically flits between arthouse and grindhouse, its plush environments at odds with the ugly emotional interiors of its protagonists. After pretending to be raped by a nocturnal prowler, Felicity breaks off her engagement, quits her safe, dull job and transforms the way she looks. Donning leathers, Felicity starts prowling the city at night-time herself, in a warped bid to take some control of the life her parents have so far dominated. The park that shares her home suburb's name, part of the larger Centennial Parklands, plays a pivotal role in Felicity's journey of self-discovery. Though it's on her doorstep, the park is, metaphorically, light years away from 'home'. The winos, copulating couples, bikies and drifters Felicity encounters after dark both attract and repulse her. Cast as a jungle netherworld within a concrete wasteland, Centennial Park is the ideal location for Felicity's exploration of her ID. •*Neil Mitchell*

Photo © Panoramio

Directed by Jim Sharman
Scene description: 'And fuck you, God, for holding out on me'
Timecode for scene: 1:12:10 – 1:14:36

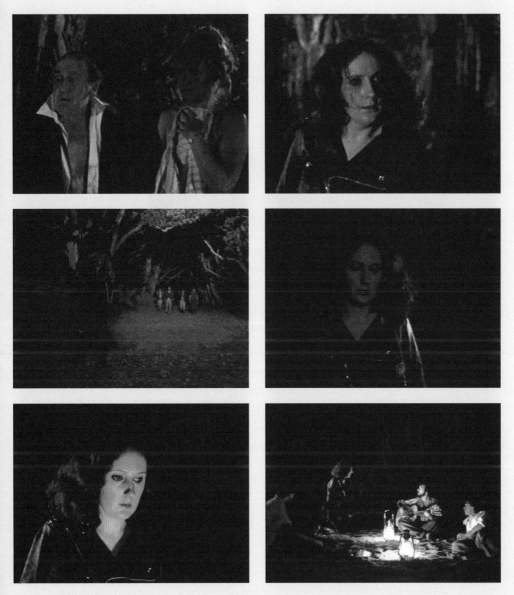

PUBERTY BLUES (1981)

LOCATION *Cronulla Beach, Kurnell NSW 2231*

AS SINGER SHARON O'NEILL sweetly croons the film's title, *Puberty Blues* opens on its most distinctive, definitive setting: Cronulla Beach. Bruce Beresford's feature adaptation of Gabrielle Carey and Kathy Lette's coming-of-age novel may base only a portion of its scenes amidst the golden sands and rushing seas; however the mystique of the space where the land meets the ocean – and the carefree lifestyle it represents – lingers over the entire film. That intoxicating allure manifests in its protagonists, 16-year-olds Debbie Vickers (Nell Schofield) and Sue Knight (Jad Capelja), as they navigate the perils of high school hierarchies, first flourishes of love and the desperate need to be accepted by the popular crowd. Debbie and Sue traverse the busy shoreline in the film's first minutes, weaving through sunbathers young and old to emerge at the end favoured by their peers. Their entire quest is laid out before them, reinforced by Debbie's narration when the titular tune ends: they want to break free from the ordinary, and ascend to sit amongst the best surfies and the prettiest girls whatever the cost. Beresford visually depicts all aspects of their simple walk, from their standing as mere faces amongst the masses of families, tourists and locals, to their lust for the water and those within its midst, to their incursion on the turf of those they covet – and the initial rejection that results. The iconic Cronulla Beach is more than a picturesque place for their stroll to play out – it is a character in their story.
➼ Sarah Ward

Photo © Panoramio

Scene description: Debbie and Sue explore the hierarchy of the beach
Timecode for scene: 0:00:00 – 0:03:34

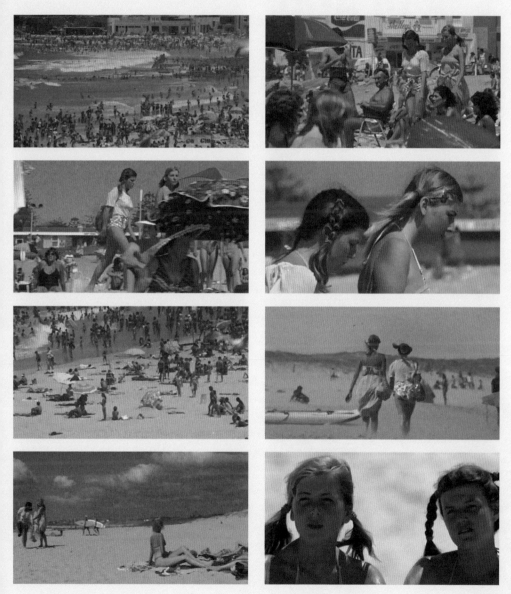

Images © 1981 Limelight Productions (II)

LIFE'S A BEACH...

Text by
DEB
VERHOEVEN

SYDNEY IS A LITTORAL CITY. Defined in equal measure by shell-grit and froth, the city is skirted by no less than a hundred lapping beaches. One or two of these have determinedly prized themselves from Sydney's sandy pull to become internationally iconic 'branded beaches', due in no small part to their repeated appearance on screens of different sizes. Bondi, Manly, Coogee, Palm, Cronulla are beach names with a notoriety that now extends well beyond their shores.

But despite this swell to international recognition, cinematically speaking Sydney's beaches haven't always embraced their place in the sun, occasionally preferring to perform as sandy stand-ins for other times and locations. Charles Chauvel's World War I epic *40,000 Horsemen* (1940) used the Cronulla sand dunes to re-stage the Sinai Desert battles of the Australian Light Horse, as commanded by the film-maker's uncle, Sir Harry Chauvel. In *The Great Gatsby* (Baz Luhrmann, 2013) Botany Bay doubles for Long Island. *Mission Impossible II* (John Woo,

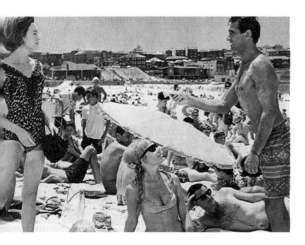

2000) used various harbourside locations as substitutes for a range of global locations.

In their chameleonic replacement of one beach with another these films contribute to the idea that the beach itself encompasses the essence of universality. In contrast to the hard-headed manoeuvres of city life, the beach offers the solace of metaphysics – the watery release of r-birth, the distant horizons that beckon toward transcendence, the tidal rhythms that hint of universals beyond contemporary mundane existence.

On the other hand, cities are usually defined cinematically as built environments with shaky moral foundations. The cinema's most celebrated city genres such as the early skyscraper movies, film noir and disaster movies are typically set deep in the shadows cast by the foreboding high-rise of inner city neighbourhoods and ghettoes. It is the rigid structuring of cinematic and urban space in the city films that alternately frustrates and enables the upward aspirations of their characters. Or, in the case of disaster movies, their most destructive tendencies

In this context Sydney's beach films present a particular conundrum. How might the sunny cloudless skies of the beach rework the alignment of modernity, cinema and urbanism that typify the 'city films'? How might Sydney's defining locational asset, its celebrated shore, reconcile the universality of the beach with the granular specificity required of the city film?

Into this paradox steps *Palm Beach* (Albie Thoms, 1980) artfully mixing mean street milieus with surfing subcultures. Named for the actual location in which it was shot, this beachside thriller weaves three separate but overlapping stories in a documentary styled exposé of the souring experiences of seachangers that emphasizes the artistic and thematic aspects

of thinking small. It's not a surprise that the press kit for the movie included a map of the beach surrounds, the same sites that have found subsequent fame as the perennially beaming location of Summer Bay in the long-running Australian soap *Home and Away*.

As a location, Palm Beach also shares the distinction of being a bit of an industry self-reference. Much of the talent of the Sydney production scene lived there at one time or another. During the 1970s, as the Australian film industry climbed the crest of its "last new wave", Palm Beach hosted high achievers such as Peter Weir, Philip Noyce, Jan Sharp, David Elfick, Lissa Coote, Albie Thoms, Wendy Hughes, Chris Haywood, Pat Lovell, Mike Harris, Tom Cowan, Annie Brooksbank and Bob Ellis.

In contrast to the hard-headed manoeuvres of city life, the beach offers the solace of metaphysics – the watery release of rebirth, the distant horizons that beckon toward transcendence, the tidal rhythms that hint of universals beyond contemporary mundane existence.

Bryan Brown who featured in *Palm Beach* later moved on to star in *The Empty Beach* (Chris Thomson, 1985) playing crime novelist Peter Corris's PI, Cliff Hardy. Despite some inspired dialogue ("I'm goin' to Bondi – wanna come?' 'Nah – I don't speak New Zealand') the film laboured to survive the transition from shelf to shoreline.

Perhaps the greatest exemplar of the beach-crime movies to come out of Sydney is the

Italian-Spanish *giallo* film *La Ragazza dal pigiama giallo/The Pyjama Case Girl* (Flavio Mogherini, 1977). The film is loosely based on a much earlier 'true crime' mystery that occurred in Melbourne in 1934. Transplanting the action to 1970s Sydney, the film begins and ends at the seaside, which is luridly depicted as a soulless place of innocence lost.

International (off-shore) productions are not new to Australia and perhaps one of the most historically resonant is Michael Powell's *They're a Weird Mob* (1966). Ostensibly the story of a post-war Italian migrant finding his feet as a newly landed arrival, the film is perhaps much more interesting as a contemplation of the post-war non-migrant Australian. A voyeuristic scene on the crowded Bondi Beach nods to the fashion for Hollywood "beach party" movies at that time, further amplifying the films' international interests

Margot Nash takes the theme of migration in *Vacant Possession* (1996) to a much earlier incarnation by exploring the persistent legacies of European colonisation through a layered family reconciliation drama. It's no coincidence that the film is shot amidst the mangroves and dunes of Kurnell near Botany Bay and close to where Captain Cook fatefully landed.

More recently, *Bondi Tsunami* (Rachael Lucas, 2004) tracks another wave of visitors, Japanese surfers looking for epic breaks and personal salvation. The movie's inspired, zany, solar enthusiasm flickers energetically between existential reflection and self-mockery. It's weird geographical juxtapositions remind of an earlier, largely forgotten Japanese movie set in Australia, one of two made in the late 1960s, 燃える大陸/ *Blazing Continen*t (Moeru Tairiku and, Shogoro Nishimura, 1968) which also makes a journey from Sydney's sandy fringes to Australia's sandy centre.

Finally, if any one film can be said to have quintessentially captured Sydney's beach cinema it is *Puberty Blues* (Bruce Beresford, 1981), now enjoying a third life as a TV series. Originally a novel written by Kathy Lette and Gabrielle Carey the film portrays Cronulla as a peer group proving ground at a time when teenagers still surfed the ocean rather than the internet. The two lead characters, Debbie and Sue, struggle to escape the 'serf culture' they once longed to join ("There's got to be more to life than just surfing"). In *Puberty Blues* it is not (yet) the beaches that are toxic but the beach culture they sustain. �֍

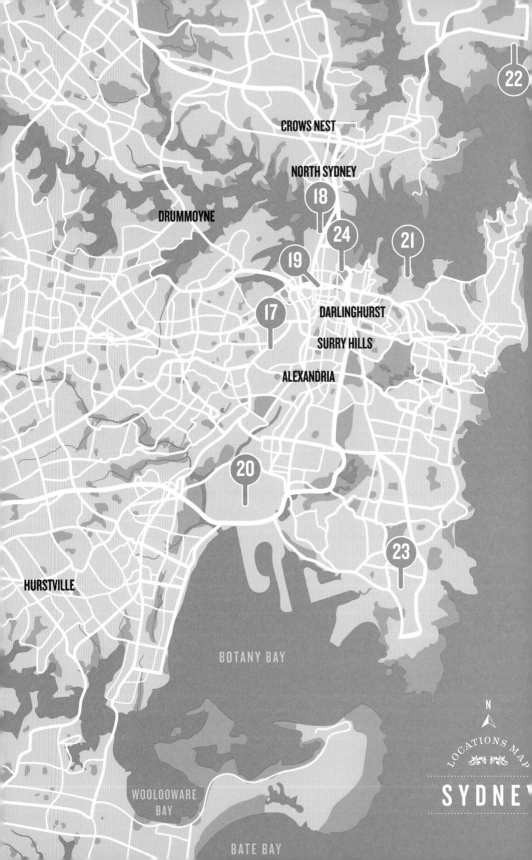

CROWS NEST

NORTH SYDNEY

DRUMMOYNE

18

24

19

21

17

DARLINGHURST

SURRY HILLS

ALEXANDRIA

20

23

HURSTVILLE

22

BOTANY BAY

N

LOCATIONS MAP

SYDNEY

WOOLOOWARE
BAY

BATE BAY

SYDNEY LOCATIONS

SCENES
17-24

maps are only to be taken as approximates

HEATWAVE (1982)

Georgina Street, Newtown, NSW 2042

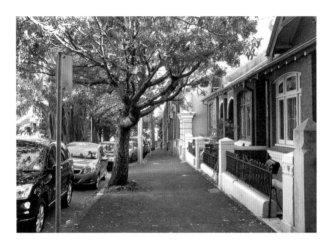

'WHY ARE WE BEING FORCED OUT OF OUR HOUSES?', shouts Kate (Judy Davis) from a terrace block's rooftop to the locals and media below. As she is dragged down, architect Stephen (Richard Moir) and his wife watch the TV news coverage of these events from their luxurious McMahons Point home (a perfect harbour view visible in the background), before Stephen turns back to the blueprints for the $200 million Eden Project that he hopes will replace those old inner-city buildings. The early 1980s saw a race to make a film based on the cause célèbre of Juanita Nielsen, a journalist whose campaign to stop housing developments in Victoria Street, Kings Cross ended in 1975 when she vanished without trace. Pipped to the post by Donald Crombie's *The Killing of Angel Street* (1981), *Heatwave* never quite gels as a conspiracy thriller, but works just fine as a broader allegory dressed in the guise of recent local politics. For much as the Victorian terrace houses of Newtown's Georgina Street serve here as proxies for the similar 'filigree style' buildings of Victoria Street, so *Heatwave*'s torrid tale of land grabs, class conflict and deep-seated corruption is as old as colonization itself, suggesting an Emerald City, and a nation, ever built on compromised utopianism – and on dead bodies. After all, as Mary (Carole Skinner), the Nielsen figure of the piece, puts it to Stephen in a later scene: 'The issues are the same – the only thing that changes are the battle lines.' **Anton Bitel**

Photo © Panoramio

Directed by Phillip Noyce
Scene description: Protest from the rooftops
Timecode for scene: 0:04:54 – 0:07:16

STARSTRUCK (1982)

LOCATION *The Harbour View Hotel, 18 Lower Fort Street, The Rocks, NSW 2000*

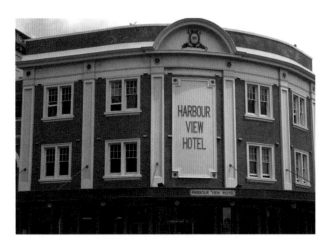

IN STRIKING CONTRAST to her debut feature *My Brilliant Career* (1979),
Gillian Armstrong's second film, *Starstruck*, is a post-punk Ocker musical
spectacular. Set in The Rocks' Harbour View Hotel at the foot of the iconic
Harbour Bridge, the film tells the story of waitress Jackie (Jo Kennedy)
and her 14-year-old cousin – and self-appointed manager – Angus (Ross
O'Donovan) on their journey to make Jackie a successful pop star. *Starstruck*
offers a frenzy of intoxicating visuals, and its radiance bleeds into characters
like Pearl (Margo Lee), Nana (Pat Evison) and the pub regulars who in other
contexts might be mistaken for banal figures. Not until Baz Luhrmann's
Strictly Ballroom (1992) a decade later did Australian cinema embrace the
phrase 'local colour' more literally. Reflecting the film's joyful celebration of
shiny surfaces, the bright Harbour Bridge mural inside the pub is granted far
more attention than the boring old grey real one at Jackie and Angus's front
door. This continues across a range of the film's core elements: its passion
for neon, its new wave rainbow clothing and hairstyles, and of course, the
vibrancy of Jackie herself. As she launches into Tim Finn's top-ten hit 'Body
and Soul' from the film's soundtrack, the secret to *Starstruck*'s irresistible
charm is revealed: in the Harbour View Hotel, Armstrong has constructed a
space where cross-generational Australia can unite. The humour and warmth
that saturate the film stem from a celebration of the past, present and most of
all its future, the latter represented so memorably in the glittering ambitions
of Jackie and Angus themselves. •◦*Alexandra Heller-Nicholas*

Photo © Shannon & Caitlin Neeson

Directed by Gillian Armstrong
Scene description: Body and Soul
Timecode for scene: 0:34:20 – 0:40:07

UNDERCOVER (1984)

Regent Theatre, 487–503 George Street, NSW 2000

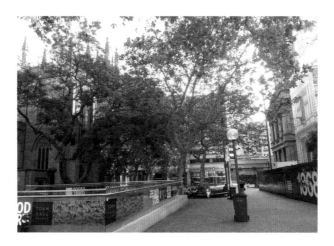

UNDERCOVER PROVIDES A LIGHT-HEARTED, episodic but intermittently fascinating portrait of both 1920s Australia and the forces of nationalism, modernism and globalization that helped redefine it. It takes the story of the rise of entrepreneur Frank Burley, and his women's underwear company (Berlei), as the foundation for a movie that explores the place of women in Australian society, the influence of Americanization on local manufacturing and the 'promotion of Australian-made products on the national and world stage'. *Undercover* is notable for its interiority and emphasis on highly designed and manufactured spaces. This focus reaches its apotheosis in the final extended scene that stages the launch of the Berlei 'True to our type' range. The final 'spectacular' moves restlessly between the extravagantly costumed models and dancers onstage and the various figures and intrigues occurring behind the scenes. This sequence shifts *Undercover* towards the musical and the kinds of closure or conflation the genre routinely insists upon between the public and the private, the performer and the audience. But this final sequence also highlights, somewhat ironically, the history of its own location. It was filmed, though not set, in the Regent Theatre, the flagship venue for Hoyts cinemas in Sydney that was opened to much fanfare in March 1928. By the time *Undercover* was filmed the venue had largely ceased operating as a cinema and was soon demolished. Despite the triumphant nostalgia and hermetically appealing romantic closure of the film's final moments, it is also possible to sense the inevitable passing – in the last image of a falling curtain and the subsequent slow fade to black – of homegrown production. ⇥*Adrian Danks*

Photo © Sam McCosh

Directed by David Stevens
Scene description: 'True to your type'
Timecode for scene: 1:10:23 – 1:21:36

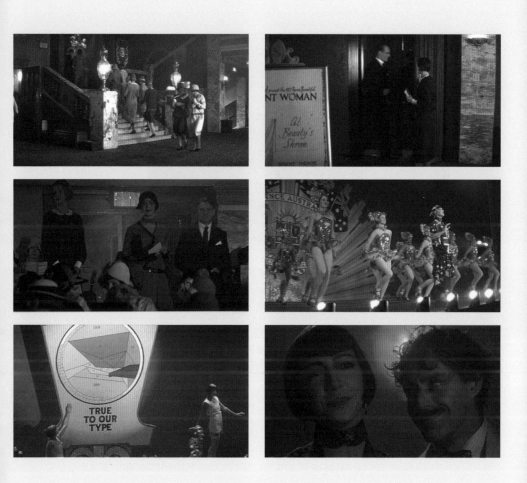

GOING DOWN (1983)

LOCATION *Sydney Kingsford-Smith Airport, Mascot, NSW 2020*

HAYDN KEENAN'S INDEPENDENT FILM *Going Down* follows four young women coming of age within Sydney's urban fringe in the early 1980s. It is awash with an Australian post-punk subculture that is unique to its temporal and geographical location but remains beautifully resonant to contemporary audiences. The film follows Karli (Tracy Mann), who is moving to New York to escape the excess of her inner-city life. The action takes place over her last evening in Sydney as her three friends take her out for one last drug-fuelled night on the town. The four girls begin the night at the same nightclub on Kings Cross but gradually disperse through their revelry. As dawn breaks, they all find themselves in different states of consciousness and in different parts of the city. Karli is forced to venture to the airport alone and is faced with the possibility of not saying goodbye to her friends. However, at the last minute they all emerge at the airport to say farewell. One of the oldest continually operating airports in the world, Sydney's Kingsford-Smith Airport first started operating out of a canvas hangar in 1919. Nowadays it is the busiest airport in Australia, and, as in this film from 1983, it remains a place where wild nights end and adventures are begun.
↔ Whitney Monaghan

Directed by Haydn Keenan
Scene description: Karli's friends say goodbye
Timecode for scene: 1:25:50 – 1:30:46

 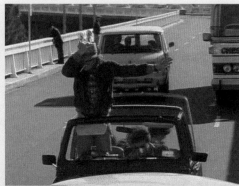

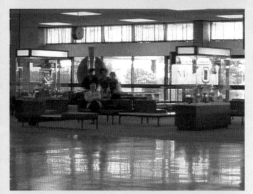

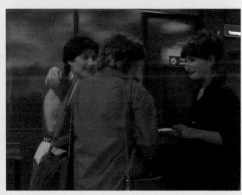 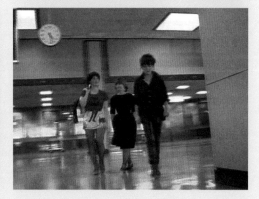

Images © 1983 X Productions

CAREFUL HE MIGHT HEAR YOU (1983)

LOCATION *Babworth House, 1 Mount Adelaide Street, Darling Point, NSW 2027*

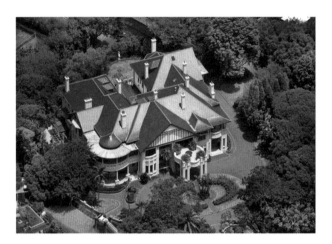

CAREFUL HE MIGHT HEAR YOU tells the tale of a young boy, P.S. (Nicholas Gledhill), squabbled over by his aunts after the mysterious death of his mother, while also providing an epic but intimate vision of Sydney in the 1930s. P.S. is shuttled between the modest Neutral Bay home of down-to-earth Lila (Robyn Nevin) and the lush, almost Gothic residence of the sexually inhibited but wealthy Vanessa (Wendy Hughes). The film is dominated by the contrast of these two environments: one cramped but open to the outdoors and free of closed-off spaces, the other a monolithic, imposing edifice in the Arts and Crafts style. The imposing order of the house – itself a then vacant mansion in the upper-class harbourside suburb of Darling Point – is finally dismantled in the closing extended sequence that follows Vanessa's sudden death in a ferry accident. This sequence is marked by the final emergence of P.S. into something like full consciousness, his response to the Kane-like boxing away of his aunt's possessions more complex and conflicted than we may have expected. This is underlined in the final moments when, after a brief exchange in which P.S. seeks out and asserts his proper name – following the departing advice of his aunt to 'Find out who you are P.S. and you'll know how to love someone else' – he exits the house. As the credits roll, the film 'opens up' and matches his liberating run through the house's gardens with a delirious fusion of 1950s-style score and fast-tracking camera movement, an invigoratingly full-bodied embrace of the excesses of classical melodrama. ➥*Adrian Danks*

Photo © www.realestate.com.au

Directed by Carl Schultz
Scene description: "Who am I?"
Timecode for scene: 1:41:46 – 1:48:05

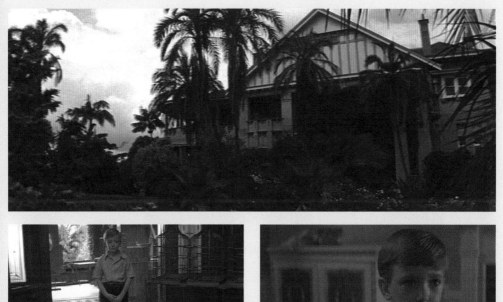

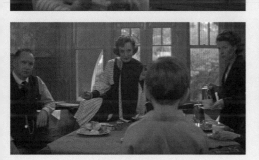

Images © 1983 New South Wales Film Commission, Syme International Productions

BMX BANDITS (1983)

LOCATION *Manly Waterworks, West Esplanade & Commonwealth Parade, Manly, NSW 2095*

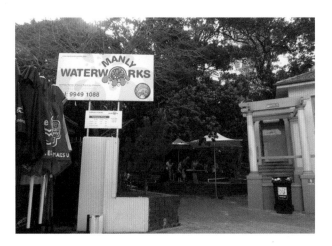

DIRECTOR BRIAN TRENCHARD-SMITH took a break from the Ozploitation fare that he is commonly associated with when he was hired to shoot the kids adventure movie *BMX Bandits*. Trenchard-Smith persuaded the producers to let him change the script's original Melbourne setting to Sydney, in order to take advantage of the city's more diverse locations and terrain. The director also cast a young Nicole Kidman in her first role as Judy, one of three BMX riding kids who foil a planned bank payroll robbery after coming into possession of police band walkie-talkies belonging to a gang of criminals. A knockabout romp featuring fun-loving kids, buffoonish villains and overly officious policemen, *BMX Bandits* also includes numerous action set-pieces unfolding in locations such as Westfield Warringah Mall in Brookvale, Sydney Harbour, the Corso promenade area in Manly and the Northern Beaches. Conforming to Trenchard-Smith's desire to show BMXs in places BMXs shouldn't be, probably the most memorable of these sequences involves an extended chase sequence that passes through Manly Waterworks. The popular theme park, once run in conjunction with the now closed Mount Druitt Waterworks and Cairns Waterworks, provides an unusual escape route for Judy, P. J. (Angelo D'Angelo) and Goose (James Lugton) from their bungling pursuers, Whitey (David Argue) and Moustache (John Ley). Diving into one of the park's three waterslides with their bikes in tow, the gang enjoys the thrill of the ride before cycling away, a very bedraggled Moustache flailing in their wake. ◆*Neil Mitchell*

Photo © Shannon & Caitlin Neeson

Directed by Brian Trenchard-Smith
Scene description: Making a splash at Manly Waterworks
Timecode for scene: 0:50:36 – 0:53:14

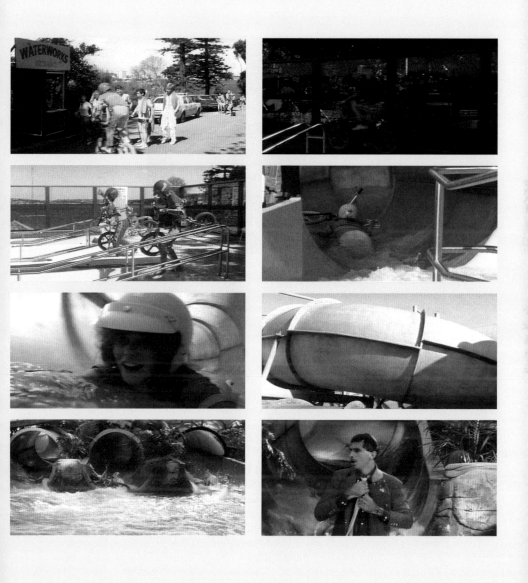

BLISS (1985)

LOCATION *Royal Botanic Gardens, Mrs Macquaries Rd, NSW 2000*

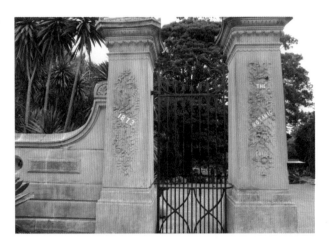

BASED ON PETER CAREY'S 1981 NOVEL, the ecologically themed *Bliss* begins with its hero, storytelling adman Harry Joy (Barry Otto), having a heart attack in his garden and experiencing the rise of his spirit from his body, up through the leaves of the trees above. Resuscitated and returned to earth, Harry grows convinced that he is being punished in a hell on earth, and gradually removes himself from the domestic and professional spheres that had once been his life's unquestioned mainstays. First he takes refuge in the back shed, before leaving his home entirely for a luxurious hotel suite – and then, when his family keeps sending doctors to section him, he slips away each morning from the hotel too, on the advice of his new lover, the rainforest-dwelling hippy and part-time call girl Honey Barbara (Helen Jones). In one fluid tilt that imitates (and reverses) Harry's earlier spiritual flight, the camera passes from Sydney's high-rises down through a canopy of leaves and branches to Harry and Barbara, sitting beneath a palm-tree stand, listening together to the dawn chorus. Nestled improbably beneath the urban skyline, the Royal Botanic Gardens here function as a heavenly oasis in an urban hell, their Edenic verdure and birdsong offsetting the steel and concrete still visible through the trunks of the trees. It is the one place where Harry is beyond the reach of his demons – until, that is, he later flees once more, this time deep into the rainforest where Barbara lives. ••*Anton Bitel*

Photo © Shannon & Caitlin Neeson

Directed by Ray Lawrence
Scene description: Harry Joy and Honey Barbara take refuge at dawn
Timecode for scene: 1:14:12 – 1:14:57

DEAD END DRIVE-IN (1986)

LOCATION *The Star Drive-In, 4 Wassell Street, Matraville, NSW 2036*

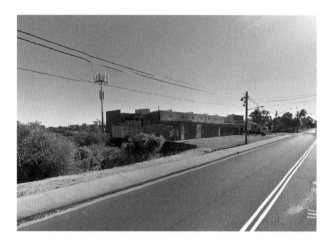

BASED ON PETER CAREY'S 1979 story 'Crabs', *Dead End Drive-In* is set in a 1988 dystopia of societal breakdown – and yet its principal location, a drive-in cinema, was an institution already well on its way out by the time of the film's 1986 release, as was, at least for the time being, the kind of fare that would typically show there. So despite its future setting, *Dead End Drive-In* also casts an elegiac eye back over the whole 'Ozploitation' movement. Nostalgia thick as petrol fumes can be discerned from the moment Jimmy 'Crabs' Rossini (Ned Manning) and his girlfriend Carmen (Natalie McCurry) roll up at the (then closed down, now demolished) Matraville Star Drive-In in a red 1956 Chevrolet convertible. As Carmen flashes her tits and straddles her lover while someone, unseen but for his boots, stalks outside, the film self-consciously rehearses tropes familiar from the sort of scuzzy exploitation typically exhibited at drive-ins. Conversely, Crabs's own situation is reflected in snatches, glimpsed on the Star's screen, from Trenchard-Smith's earlier Ozploitationer *Turkey Shoot* (1982). As the Chevy pulls in, it is choreographed to the arrival, projected on-screen, of a prison van; and as Crabs realizes that policemen, rather than delinquents, just stole his tyres, the film-within-a-film shows a man suspended from a tree by a rope. In this outdoor theatre repurposed as a holding centre for its unsuspecting patrons, the trap has already been sprung, and Ozploitation has nowhere left to go. ➻*Anton Bitel*

Directed by Brian Trenchard-Smith
Scene description: *Crabs and Carmen arrive at the Star Drive-In*
Timecode for scene: 0:15:50 – 0:20:48

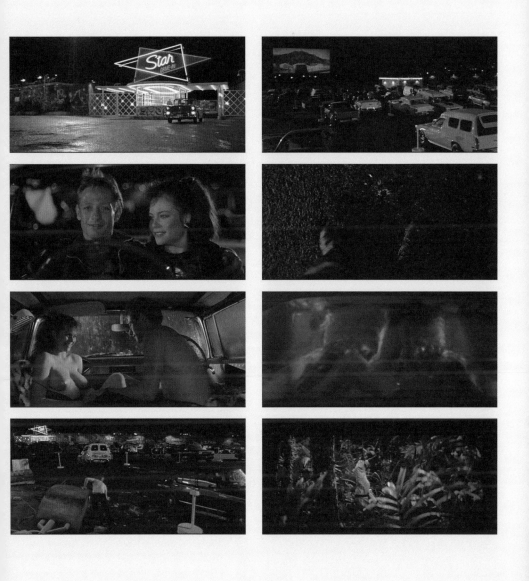

SOJOURNER SYDNEY

Text by
JANE
MILLS

Looking from the Outside

SYDNEY IS REPUTEDLY BOLD AND BRASSY – all beach bums, babes and bottles of bubbly while bobbing up and down on the harbour with those iconic photo-opportunity locations, the Harbour Bridge and the Opera House, as backdrop. This contrasts with the auguably less distinctive but more intellectual and yes, more *cultured* Melbourne. The competitive relationship between the two cities idealises and denigrates both: if Melbourne is all fur coat, Sydney is no knickers, as the saying goes.

What Sydneysiders think of their city largely differs from the tourism brochures. Capturing some of the city's complexity, Michael Thornhill's poetic social realism in *The F.J. Holden* (1977) shows working-class life in the western suburbs as both bleak and fun – providing you're a boy, that is. Bruce Beresford, another local, exposes the darkness beneath the glitter in *Puberty Blues* (1981): behind the sun, surf and sex at Cronulla lurks ugly, violent sexism – eventually ameliorated by two emerging feminists (in bikinis, naturally).

But what of non-natives – are they seduced by the brochures? Macau-born emigrant Clara Law's western suburbs in *A Floating Life* (1996)

warn would-be assimilating New Australians of certain death by spider, dog, snake and sunshine. And there's little poetry in Vietnam-born Khoa Do's western suburbs – Cabramatta, Fairfield, Flemington – in *The Finished People* (2003), *Footy Legends* (2006) and *Mother Fish* (2010) whose multi-ethnic, non-English-speaking characters live in sad housing-commission dwellings, the backs of cars and on the streets. From boat-person to 'Young Australian of the Year' in 24 years, Do is a relic from when Sydney welcomed those fleeing persecution in their homelands.

Short-stay sojourners who visit as guests for as long as it takes for them to make a film in and about their host city also have to negotiate the blandishments of a touristic, 'Destination Sydney' mentality. Informed by notions of location, dislocation and relocation, and place, displacement and replacement, these outsiders aren't exilic, refugee or immigrant film-makers, however porous these categories are conceptualized.

British visitor Michael Powell is perhaps the best-known sojourner in the post-war period when few Australian films were made. Based on the 'autobiography' of an Italian immigrant (actually, Irish Australian John O'Grady), *They're a Weird Mob* (1966) casts an affectionate, if satirical, eye on the city. Immigrants' postcards home insisted 'wish you were here' but on the Manly Ferry a drunk, white Aussie tells them to 'go back to your own bloody country'; and the Bondi lifesavers strutting their stuff in cute red-and-yellow caps never looked more absurd.

For most sojourner film-makers, the outback – simultaneously 'exotic' and 'authentic' – proved the more attractive location. A shot from North Head Scenic Drive, Manly in British Harry Watt's *The Overlanders* (1946) is barely memorable after seeing the film's wonderful desertscapes. Canadian sojourner Ted Kotcheff's *Wake in Fright* (1971) portrays a dislocated, despairing schoolteacher stuck in a godforsaken, drought-riven outback

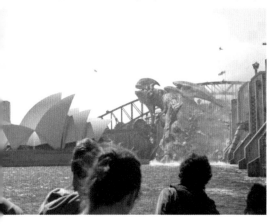

town (Broken Hill, NSW). He briefly fantasizes about his girlfriend who, in a series of flash cuts, springs Botticelli-like from the sparkling Bondi waves: an easy pick-up shot only a few minutes from the post-production Ajax studios at Bondi Junction.

The Rocks, with its heritage sandstone buildings and proximity to the Harbour Bridge, has attracted almost fifty TV and film-makers of which sojourners include Hong Kong director John Woo (*Mission Impossible II* [2000]) and Hindi directors Siddarth Anand (*Bachna Ae Haseeno/Watch Out Girls, I'm Coming!* [2008]) and Farhan Akhtar (*Dil Chahta Hai/Do Your Thing* [2001]) – doubtless attracted to these locations to please the large 'Indian Living Overseas' (ILO) audiences' appetite for Bollywood fare.

Mostly, however, the Harbour Bridge symbolized escape from civilization. In British Lesley Norman's *The Shiralee* (1957) it sheds an ominous shadow over Jim Macauley (Peter Finch) who longs to escape emotional responsibility in the city. American Lewis Milestone filmed here for *Kangaroo* (1952) before fleeing to the South Australian desert for his 'Western'. And sojourner Nicolas Roeg's *Walkabout* (1971) is memorable for its beautiful desert images and dislike of the city. Opening and closing scenes depict unhappy, white characters in a soulless Sydney which, despite shots of Circular Quay, the Botanic Gardens, the Governor's

residence, Australia Square and the Vaucluse foreshore with the Harbour Bridge behind, is referred to as Adelaide.

This sense of Sydney as an 'elsewhere' location imbues the films of recent sojourners, lured to Sydney mainly because computer graphic technology can turn it into 'anycity'. Visiting directors like the Wachowski Brothers (*Matrix* trilogy [1999–2003]) and Bryan Singer (*Superman Returns* [2006]) depict Sydney as an anonymous 'megacity' although the many film-location aficionados can take you on a virtual step-by-step tour of the films' locations. John Woo's *Mission Impossible II* shows a recognizable and glamorous Sydney but he was, after all, filming Tom Cruise, then an honorary Australian courtesy of his now ex-wife, our Nicole, at the Opera House, Mrs Macquarie's Chair and Botany Bay's Bare Island. Such sojourners are less interested in the city's physical beauty (or ugliness) than in economically seductive labour and location deals.

But better destroyed than ignored. Sydney's status as a world-class location is assured when Kaiju monster in *Godzilla: Final Wars* (Ryûhei Kitamura, 2004) savages several CBD locations including the Cahill Expressway (for which most Sydneysiders would be sincerely grateful) and is only destroyed after totalling the Opera House. Sydney's streets are indeed mean when there's a Kaiju about. In an early scene of *The Day the Earth Stood Still* (Scott Derrickson, 2008) the Harbour Bridge again gets destroyed. (Hearing the audience cheers as I viewed this in Melbourne, I had never felt more 'othered'.) But perhaps the director enjoyed his sojourn because it reappears completely repaired in the final scene.

Not all outsiders depict doom and destruction in Sydney, and the top accolade here goes to English director Danny Boyle for his final shot in *Sunshine* (2007). Apparently filmed from a fictional parkland on the western side of the harbour, it was originally shot in snow-covered Stockholm and added in post-production. The sun rises on the Opera House sails as the earth slowly warms up after being nearly destroyed by ecological disaster. A character says, 'So if you wake up one morning and it's a particularly beautiful day, you'll know we made it.' That's what Sydney can be like. When reality matches the tourist brochures, Sydney takes your breath away. But it seems to need an outsider, someone just passing through, to show the rest of the world. ✠

The sense of Sydney as an 'elsewhere' location imbues the films of recent sojourners, lured to Sydney mainly because computer graphic technology can turn it into 'anycity'.

CROWS NEST

NORTH SYDNEY

DRUMMOYNE

26

25

27

28

32

30

DARLINGHURST

SURRY HILLS

ALEXANDRIA

31

29

HURSTVILLE

BOTANY BAY

N

LOCATIONS MAP

SYDNE

WOOLOOWARE
BAY

BATE BAY

SYDNEY LOCATIONS

SCENES 25-32

maps are only to be taken as approximates

EMERALD CITY (1992)

LOCATION *State Theatre, 49 Market Street, NSW 2000*

ALTHOUGH ONE OF THE COUNTRY'S most successful screenwriters, Colin Rogers (John Hargreaves) feels his career is at an impasse, so he, his publisher wife Kate (Robyn Nevin) and children move from Melbourne to Sydney in an effort to revive his fortunes. Adapted from David Williamson's loosely autobiographical stage play, *Emerald City* toys with the inherent traditional belief of Melbourne as a city of culture contrasted with the superficial excess of Sydney, with those lured to the harbour city rarely immune to its seductive allure. Although mostly consisting of interiors, the film expands on its theatrical origins by the inclusion of a number of Sydney locations with many centred around and on the harbour, the view of which is mandatory for the home or office of those who have succeeded in this city. However, the crucial space is the foyer of the State Theatre, at the opening night of the annual Sydney Film Festival. The key sequences at this location are strategically placed throughout the film, functioning temporally and spatially: here is where Colin meets the crass, commercial huckster Mike (Chris Haywood) who is attempting to gain a foothold in the industry and his striking young girlfriend Helen (Nicole Kidman). Over the course of the three opening nights (spanning two years) Colin has been seduced by money and tempted by sex but finally has his self-doubts allayed by realization of the qualities that truly matter in his life and work. With its grandly deco opulence, the State Theatre signifies the uneasy conflation of artistic integrity with economic enterprise.
↦ Dean Brandum

Photo © Shannon & Caitlin Neeson

Directed by Michael Jenkins
Scene description: When Colin met Mike
Timecode for scene: 0:07:45 – 0:12:35

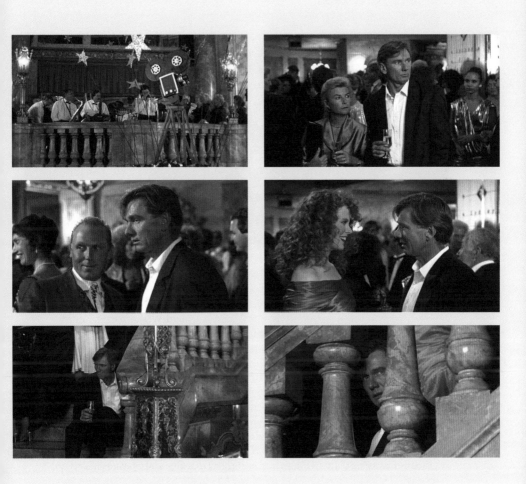

STRICTLY BALLROOM (1992)

Darling Harbour Rail Yards (now The Star Casino), Pyrmont, NSW 2009

THE MILK BAR is a quintessential location in suburban Australia. Geographically located at the very heart of the suburbs, the milk bar is more than a general store – it is a place where residents purchase their groceries, hamburgers and newspapers, yes, but it is also a place where gossip, ideas and culture are exchanged. In Baz Luhrmann's first feature film, *Strictly Ballroom*, the Toledo milk bar is the family home of Fran (Tara Morice), a beginner dancer with big dreams. On the surface her home is shabby and faded, it seems to be a solitary dwelling in the middle of an urban wasteland. Yet beyond this exterior, the location bursts with energy and soul and this is frequently juxtaposed against the vacant glitz and glamour of the world of competitive ballroom dancing. Midway through the film, Scott (Paul Mercurio) realizes that he wants to dance with Fran at the Pan Pacific Grand Prix, a prestigious dance competition. He arrives at the milk bar, is confronted by Fran's father and subsequently challenged to a Spanish dance-off in the backyard. He performs his Paso Doble and is laughed off the stage before being taught to feel the rhythm of this iconic Spanish dance. Here a cultural exchange occurs, illuminated by the coloured lights of this suburban milk bar. Nestled away in the middle of a train yard, this building was purpose built for the film and demolished soon after. Catch the bus to The Star Casino today and you'll be standing in the very spot where Scott Hastings learned to dance to the rhythm of his heart. ✦**Whitney Monaghan**

Directed by Baz Luhrmann

Scene description: : 'Come on. Show us your Paso Doble' – at the milk bar, Fran's father challenges Scott
Timecode for scene: 0:47:48 – 0:55:09

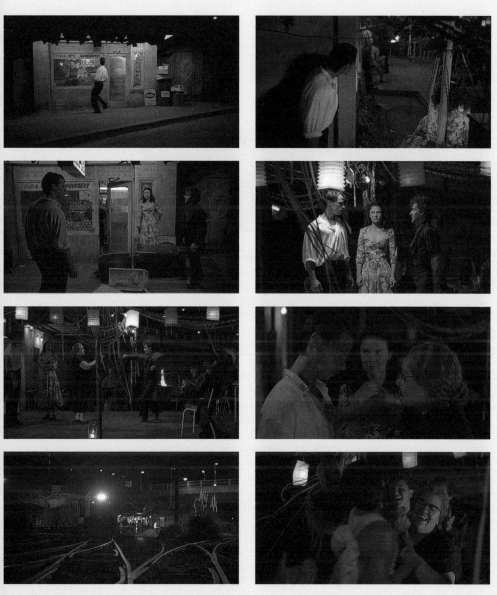

THE LAST DAYS OF CHEZ NOUS (1992)

LOCATION *Wentworth Park Sports Complex, Wentworth Park Road, Glebe NSW 2037*

FOLLOWING THE ARRIVAL OF VICKI (Kerry Fox) at her sister Beth's (Lisa Harrow) house in the inner-city suburb of Glebe, *The Last Days of Chez Nous* provides powerful insight into human nature. Armstrong's film, written by author Helen Garner, follows a number of different relationships as they unfold: between the sisters, between Beth and her father, between Vicki and Beth's husband J.P. (Bruno Ganz), and between Beth's daughter Annie (Miranda Otto) and her boyfriend. Spanning a vast emotional spectrum, these relationships are contrasted through Armstrong's emphasis on the nuanced, seemingly endless tug-of-war between intense passions, loyalties and long-held grudges. Mainly filmed on location in a terrace house in Glebe, Armstrong also strategically employs other Sydney locations, with many of the film's most significant moments occurring beyond Chez Nous's walls: for example, J.P. and Vicki develop their sexual relationship while Beth and her father are on an outback journey of discovery, and Annie and her boyfriend experience one of their most touching scenes in Hyde Park. In the scene where Beth and Vicki share a taxi ride after the latter has had a pregnancy terminated, Armstrong visually privileges the Wentworth Park Greyhound Track in Ultimo. This location implies a context of animalistic competition that foreshadows the betrayal at the heart of the sisters' relationship. While seemingly united in this fraught emotional moment, the spirit of support and solidarity between the sisters is ultimately exposed as little more than a superficial veneer when the revelation of Vicki and J.P.'s affair changes life in Chez Nous forever. **→ Alexandra Heller-Nicholas**

Photo © Sam McCosh

Directed by Gillian Armstrong
Scene description: *After the termination*
Timecode for scene: *0:30:55 – 0:32:02*

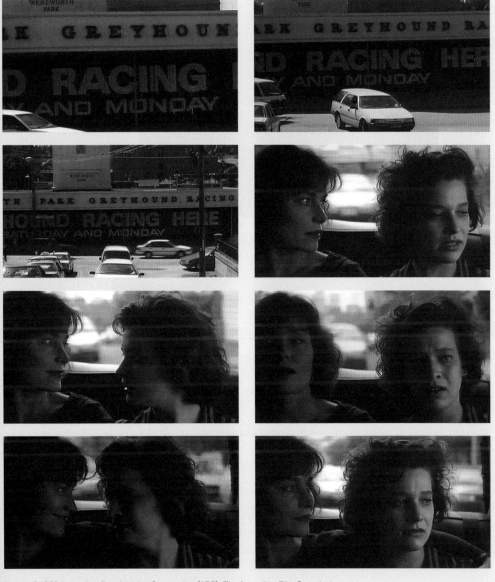

MURIEL'S WEDDING (1994)

LOCATION

St Mark's Anglican Church, to 53 Darling Point Rd, Darling Point, NSW 2027

MURIEL HESLOP (TONI COLLETTE) is getting married. Her betrothed, David (David Lapaine), is a South African athlete who can barely contain his discomfort during the sham ceremony, organized so the lad can obtain a residents' visa. For Muriel, however, it's *the* life event she has dreamed about every single day while stuck in hometown hellhole, Porpoise Spit. P.J. Hogan's modern fairy tale is laced with acerbic wit and dark themes and explores tensions between city and provincial folk. It's a variation on *The Ugly Duckling* (Hans Christian Andersen, 1843), with Muriel a young girl struggling to find acceptance among her peers. Sydney is a place where, like a lot of young people attracted to the bright lights of a big city, personal reinvention can take place without open ridicule. The wedding, filmed at St Mark's in Darling Point, an expensive suburb, sees Muriel combine her primary obsessions: getting hitched and ABBA. Walking down the aisle to hit-single 'I Do, I Do, I Do, I Do, I Do', the guests look on bemused and the bridesmaids embarrassed. So lost in the ecstasy of the occasion, Muriel completely ignores her sadsack mother, Betty (Jeanie Drynan), and only finds out best mate Rhonda (Rachel Griffiths) was there after the ceremony has taken place. These slights do have repercussions. Rhonda and Muriel's friendship is severed; at least, temporarily. The emotionally fragile mother, seen as an embarrassment and a somewhat unwanted presence, especially by her corrupt and philandering politician husband Bill (Bill Hunter), passes away without a traditional reconciliation scene between mother and daughter. **Martyn Conterio**

Directed by P.J. Hogan
Scene description: Muriel's Wedding
Timecode for scene: 1:02:59 – 1:13:48

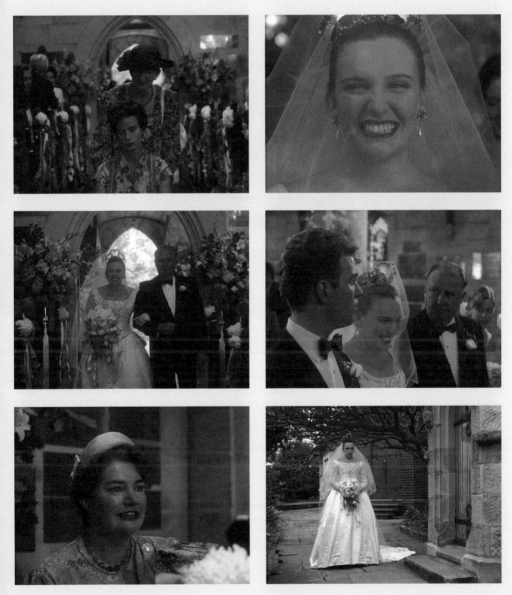

IDIOT BOX (1996)

DAVID CASEAR'S IDIOT BOX is steeped in the malaise of men without direction, of stereotypical Australian blokes saddled with the status of maturity but lacking the insight or resources to know what to do with their lives. Kev (Ben Mendelsohn) and Mick (Jeremy Sims) wallow in a cynical cycle of unemployment benefits and unfulfilling distractions – drinking at the pub, watching television, tentatively carving out unsuccessful relationships with their respective girlfriends. They want more, but are at a loss as to how to reach beyond their present state. Stealing rather than earning their happiness looms as the only achievable solution, with the disaffected duo soon immersed in the planning of a bank heist. When the time for action draws close, in tandem with the film's climax, the atmosphere of apathy still remains. 'If we don't do it now, we'll never do it. We'll just sit around and talk and do nothing,' Mick tells Kev, unaware that the police, waiting to spring upon their thievery, are monitoring their every move. They stalk around an average suburban bank, commonplace both inside and out, still reluctant to change their current state. Caesar's imagery essays the mundane nature of their method of escape from their routine, and its inevitable, predictable downfall. Inside and out, the plain building attracts attention only as a result of their intentions, the flurry of interest providing a stark contrast to its unremarkable appearance. In real life, that the bank itself is now no longer operating proves the film's point. **Sarah Ward**

Photo © Google street view

Directed by David Caesar
Scene description: Mick and Kev rob a bank
Timecode for scene: 1:09:39 – 1:19:33

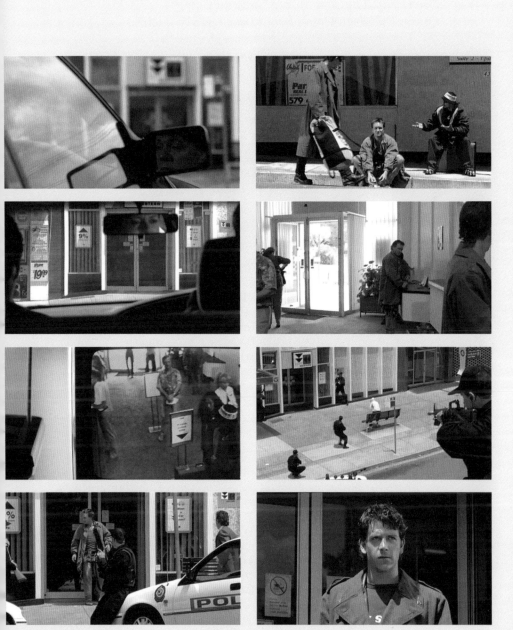

Images © 1996 Central Park Films

COSI (1996)

Bondi Pavilion Community Cultural Centre,
Queen Elizabeth Drive, Bondi Beach, NSW 2026

THE CAST OF LEWIS'S (Ben Mendelsohn) production of Mozart's *Cosi Fan Tutte* are not convinced they have the ability to perform the show. This is primarily because they are inmates of a Sydney mental health institution. So, as a form of motivation and inspiration, Lewis takes them to see a production put on by one of his amateur theatre friends, Nick (Aden Young). The outing to the Bondi Pavilion Community Centre to see Nick's play is the only time the patients are seen outside the confines of the institution. The camera (and characters) revel in this moment, following the bus down to Bondi Beach, and soaking up the wide-open space – both physically and conceptually – that is being afforded to the patients. Even the theatre space itself, though run down and 'amateur', is out in the open, literally a liberating and open place for the patients, even though they are just the audience. The scene also locates the characters momentarily back inside society, even if it is mostly within a controlled space. Some embrace the experience warmly – Roy's (Barry Otto) enthusiasm for the show; others demonstrate they are not ready – Doug (David Wenham) is quick to indulge his pyromaniac tendencies. These interwoven tendrils of open spaces, society, madness and the stage make the scene a catalyst for both the troupe and the movie's plot. Nick's performance as a 'madman' on the stage convinces the cast that the theatre is a natural platform for their madness, while the freedom they find by being outside gives them a taste of the rewards afforded to those who dare to tread the boards. **•• Daniel Eisenberg**

Photo © Ducati 749r (Panoramio)

Directed by Mark Joffe
Scene description: The cast go to see Nick's play
Timecode for scene: 0:32:17 – 0:35:10

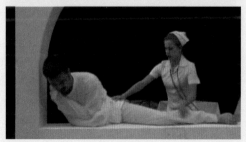

Images © 1996 Australian Film Finance Corporation (AFFC), Meridian Films

THE BOYS (1998)

LOCATION *Eastlakes Shopping Centre, 183 Evans Avenue, Eastlakes NSW 2018*

ADAPTED FROM GORDON GRAHAM'S acclaimed play, Rowan Woods's crime drama *The Boys* is a horrifyingly compelling vision of the implosion of a dysfunctional family. The rotten, violent core of the Sprague family, Brett (David Wenham) returns home after a year in prison for assault, and immediately tries to reassert his position as top dog. Brett's younger brothers, Glenn (John Polson) and Stevie (Anthony Hayes), their respective girlfriends, mum Sandra (Lynette Curran) and her Maori partner and Brett's girlfriend Michelle (Toni Collette) all come under fire as the paroled prisoner sets about reclaiming his alpha male status. A coruscating tale of power, misogyny, racism and twisted emotions told with unsettling flash-forwards hinting at an unspecified crime, *The Boys* rarely ventures beyond the four walls of the Sprague family home. The location – a property rented in the Eastern Suburb of Maroubra – acting as an oppressive hot house for Brett's corrosive presence to affect those around him. The film's night-time climax, however, takes place outside the Eastlakes Shopping Centre. Having alienated their respective partners, the brothers head out in Stevie's car, tripping on acid and driven by a collective male rage against a modern society they feel has no place for them. Aimlessly cruising around, the brothers spot a lone female approaching a bus stop at the shopping centre. With no one else around, Stevie parks the car and, amid the soulless surroundings, the final shot of the film sees Brett casually, chillingly say 'let's get her'. Being in the wrong place at the wrong time has rarely been so devastatingly portrayed as it is in *The Boys*. ➔ **Neil Mitchell**

Directed by Rowan Woods
Scene description: : 'Let's get her'
Timecode for scene: 1:16:22 – 1:19:37

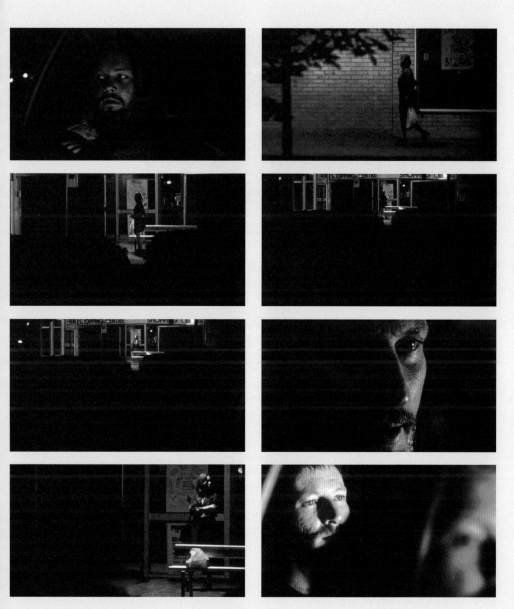

TWO HANDS (1999)

LOCATION *Sydney Monorail*

BEING PURSUED BY AN EMPLOYEE of vicious gang boss Pando (Bryan Brown), Jimmy (Heath ledger) hurriedly says 'let's go for a ride' as he guides Alex (Rose Byrne) up a set of stairs onto the monorail platform in an effort to shake him off. Jimmy and Alex jump into a carriage while the henchman stares upwards, swearing as the futuristic machine swiftly glides away. What is most notable about this scene in Gregor Jordan's crime film, particularly for a former Sydneysider like myself, is the monorail's distinctive noise; a whirring, sleek sound that increases in pitch as the carriage picks up speed. We see the city flash by as the monorail runs along its circular track far above street level, a welcome remove for Jimmy from the trouble that is chasing him. It offers both characters a moment of calm to contemplate their situation, where Jimmy and Alex can admit their feelings for one another in a safe, enclosed space; a moment of intimacy for a couple on the run. For a moment, they can pretend to escape from their problems. Their first passionate kiss ends as the camera pans to look out of the carriage window, downwards to a sinister car following the path of the monorail. This scene has poignancy in other respects, considering that the city has moved on. The monorail has now been decommissioned and dismantled, with its last run ending on 30 June 2013. It has become a part of Sydney's past, immortalized on film in the flight of a character whose actor has also sadly left us. ➥ *Erin Pearson*

Photo: Paddy's Markets Station © Ambanmba (Wikimedia Commons)

Directed by Gregor Jordan
Scene description: *Jimmy and Alex run onto the monorail to escape from Pando's henchman*
Timecode for scene: *0:53:20 – 0:56:00*

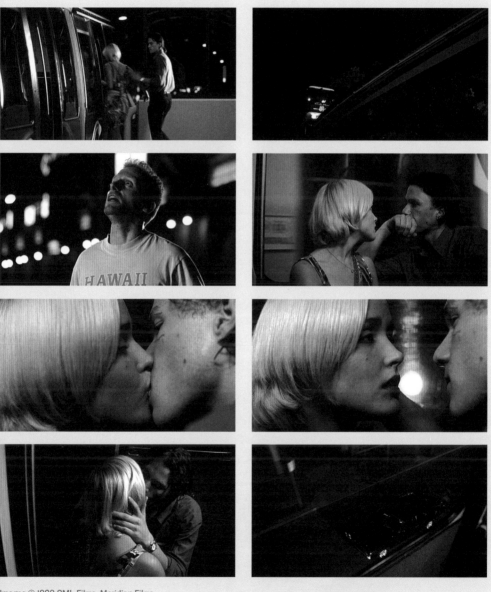

THE PHANTASM OF THE OPERA

Text by
GEMMA
BLACKWOOD

The Sydney Opera House

FOR A YOUNG NATION renowned for a cultural cringe – an old self-deprecating national joke says that the only Australian culture to be found is in yoghurt – the idea of building a massive arts complex was a big concern for the Sydney government of the post-war 1950s. This new building could inspire inventiveness on the stage, with a beautiful exterior that would be a landmark for the city. An architectural competition was started in 1955 for the creation of a new opera house building. The winner was a young Dane called Jørn Utzon, with an innovative design using the city's harbour theme of waves and yacht sails. Indeed, the complexity of the design meant the building took decades to build and was only officially opened in October 1973. For decades the building sat around in various stages of completion. John Weiley's documentary *Autopsy on a Dream* (2013) examines the painful

origins of this building, as well as the political change that led to the resignation of Utzon. Weiley explains how the high-profile building site also served as a formative film-making playground for aspiring film-makers in the 1960s and 1970s: right from its start the Opera House was linked to film.

While the building was constructed expressly for drama of the operatic kind, it didn't take long to get featured in movies. One of the first feature films to make the most of the new Opera House was the detective film *Scobie Malone* (Terry Ohlsson, 1975), which opens with a woman's body discovered crushed in the cavernous basement. Starring Jack Thompson as the womanizing anti-hero detective, this camp story (complete with its Ozploitation 1970s theme song) nods to the phantom of the opera via its peculiarly Antipodean take on the James Bond type.

Alongside the Sydney Harbour Bridge (built in 1932), the Opera House has become *the* establishing shot for the city on-screen. It is often used as an easy visual shorthand to connote 'arrival' in the great southern land. This connects to reality: for those flying into Sydney from overseas, the Opera House is one of the more obvious icons that can be seen from the air. Yes, we *are* in Australia. It is used to establish location in films as diverse as *Mission Impossible II* (John Woo, 2000), *Looking for Alibrandi* (Kate Woods, 2000) and *Crocodile Dundee* (Peter Faiman, 1986) among many others.

A view of the Opera House in film can also suggest wealth, cultural capital and power. The Opera House is situated next to the city's highest real estate. In *Crocodile Dundee* the American

journalist Sue Charlton (Linda Kozlowski) looks down at the building from her modern hotel room while she phones her editor in New York. For Sue, the building is an instant emblem of an exciting new country, whilst still a sophisticated urban marvel that helps the woman mentally transition from the jungle of Manhattan Island into the reptilian landscape of Northern Australia.

It has become convention for Hollywood disaster films to destroy real-life iconic landmarks on-screen: perhaps all the better to connect these films to verisimilitude. Some blockbuster disaster films have used the building as an easy signifier for attack on Australia. In *Independence Day* (Roland Emmerich, 1996) it lies half-crumbled from alien attack; in Guillermo del Toro's recent *Pacific Rim* (2013) it stands in a prime protection zone for the giant Australian Jaegers. Another disaster film in which the Opera House is pivotal is John Duigan's little-known Australian film *One Night Stand* (1984): in this movie, four teenagers are trapped inside the Sydney Opera House on New Year's Eve as a global nuclear war is declared. What follows becomes a strange fusion of *The*

The Opera House is situated next to the city's highest real estate. In *Crocodile Dundee* the American journalist Sue Charlton (Linda Kozlowski) looks down at the building from her modern hotel room while she phones her editor in New York.

Breakfast Club (John Hughes, 1985) meets *On the Beach* (Stanley Kramer, 1959) as they mope and reflect on their futures. 'The radiation would have died down now' notes one kid naively ten minutes after the attack begins. The film also features existential teen ruminations such as 'if we are going to snuff it I wish I could have gone overseas'. *One Night Stand* is a fascinating generic oddity of the mid-1980s, complete with Day-Glo imagery of the Opera House against a blood-red sky.

While the Opera House features in the cinematography of countless films, some of the more famous apparitions of the Opera House remain in more symbolic representations. In the Disney animated film *Finding Nemo* (Andrew Stanton and Lee Unkrich, 2003), hundreds of tiny moonfish form a phantasm of the Opera House for the Daddy clownfish to show where his tiny son might be. In this version, the sails of the House are sharp and fin-like; a reminder of shark fins and other dangers. For Nemo's dad, the Opera House becomes another extension of a highly dangerous world as he travels south from the Great Barrier Reef. And it eventually turns out that Nemo has been trapped in a Sydney fishbowl directly facing the Opera House.

A memorable depiction of the Opera House occurs in *The Adventures of Priscilla, Queen of the Desert* (Stephan Elliott, 1994). In the finale drag dance spectacular in Alice Springs the film's three unsinkable drag queens hold architectural sails and together form a version of the building. On a spiritual journey from their home of Sydney, by dressing as its most famous structure they show both union and a moving tribute to their home – a place where the Gay and Lesbian Mardi Gras has transformed the identity of the city and where they have helped carve out social acceptance and an exciting identity. By taking on the sails they literally embody the glamour of the Eastern city to the quiet town in the country's red centre.

The Sydney Opera House is a structure that is endlessly refashioned on-screen, and will likely continue to be while it enjoys such prominence in the city. These days, the sails have even become an experimental film projection space of their own: for example, arts festivals such as the annual Vivid Festival work with video artists and directors to project psychedelic imagery onto its white surfaces. The space between cinema and architecture is but a short journey: sailing fabric stretched tight; concrete celluloid. �֍

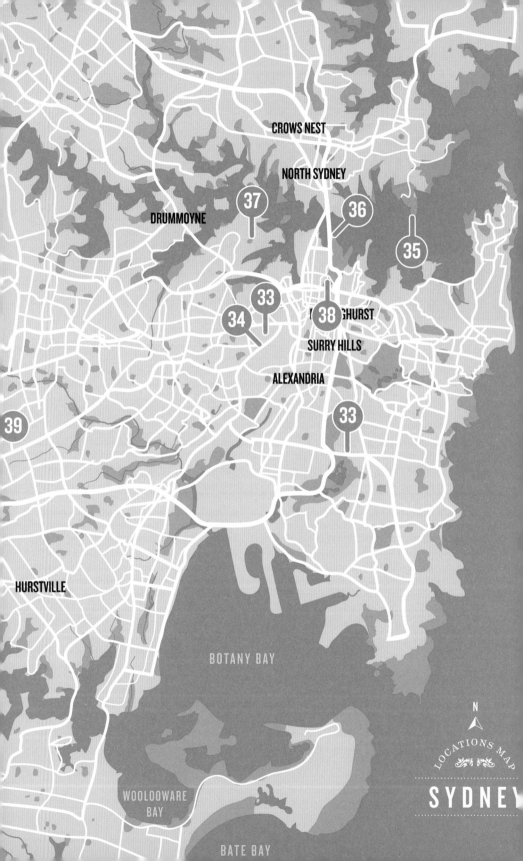

SYDNEY LOCATIONS

SCENES 33-39

maps are only to be taken as approximates

ERSKINEVILLE KINGS (1999)

LOCATION *Gould's Book Arcade, 32 King Street, Newtown, NSW 2042*

GOULD'S BOOK ARCADE and its famous left-wing activist owner, Bob Gould, are a veritable institution in Sydney. The bookstore has featured in poetry by Brook Emery, various newspaper and journal articles and even in David Foster's novel *The Glade Within the Grove*. It should come as no surprise that the store itself is the true star of this scene from Alan White's debut film. As Barky (Marty Denniss) and Lanny (Leah Vanderberg) wander around the store with Barky half-heartedly flirting with Lanny, mountains of books tower over them; they are surrounded by the stories of the past. Considering the film's constant exploration of the stories we tell – be it Trunny's (Aaron Blabey) overblown tales of kicking cab drivers or the dark story of Barky's father's death which is told by his brother Wade (Hugh Jackman) – it is apt that such an overwhelming and iconic repository of second-hand stories is used in the film. Beyond this, in what is either a cheeky cameo or just a convenient piece of casting, Gould himself sits at the front counter scowling, and watching Barky and Lanny closely on the closed-circuit cameras. Gould, who died in the store in 2011, was a major part of the anti-Vietnam movement in Australia, regularly had his bookstores (he opened twelve and closed eleven over his career) raided by police over censorship, and even helped restrain the man who attempted to kill Arthur Calwell in 1966. This sequence, nestled like another volume on the shelf amongst a narrative of family drama and male angst, preserves to celluloid an iconic Sydney location and the man who embodied it. **Daniel Eisenberg**

Photo © Shannon & Caitlin Neeson

Directed by Alan White
Scene description: Barky visits Lanny at work
Timecode for scene: 0:52:43 – 0:57:10

Images © 1999 Australian Film Finance Corporation (AFFC), Beyond Films

MY MOTHER FRANK (2000)

LOCATION *The University of Sydney Camperdown Campus, NSW 2006*

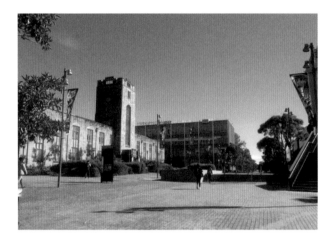

WRITTEN AND DIRECTED BY MARK LAMPRELL, *My Mother Frank* is a colourful comedy about a middle-aged widow named Francis 'Frank' (Sinead Cusack) who leads a boring and unfulfilled life in an upmarket suburb of Sydney. Her days are spent fundraising for her local Catholic church and being overprotective and meddlesome in the lives of her two adult children. To re-establish her purpose in life, Frank decides to enrol in an Arts degree and ends up at the Camperdown campus of Sydney University, the same university as her son, David (Matthew Newton). Founded in 1850, the University of Sydney is the oldest tertiary institution in Australia and its Camperdown campus is one of several campus sites across the city. Frank's first day at university is far from ideal. It begins in her son's bedroom where she tells him that she has enrolled and will be accompanying him to university that morning. He appears unenthused. When they arrive at campus, her son is embarrassed and hides, leaving Frank alone amongst the sandstone buildings and crowds of young adults. Following this, she enters her poetry lecture with a smile on her face and sits down, pen in hand, just as the lecturer concludes. However, her first tutorial is more promising and it is here that she begins to find her feet at this prominent tertiary institution. She arrives early, makes a friend and stands her ground in conversation with a professor who dislikes mature-age students. **➻ Whitney Monaghan**

Photo © Andrew Buckle

Directed by Mark Lamprell
Scene description: Frank's first day at university
Timecode for scene: 0:18:01 – 0:23:20

MISSION IMPOSSIBLE II (2000)

LOCATION *Bradleys Head, Sydney Harbour/Mosman, NSW 2000*

DURING JOHN WOO'S ACTION MOVIE SEQUEL, *Mission Impossible II*, a speed boat that brings Nyah (Thandie Newton) back to her estranged, now criminal, lover Ambrose (Dougray Scott) takes an exaggerated scenic route past the Harbour Bridge, the Opera House and other iconic harbour sights to deliver its precious cargo. This entire sequence is intercut with Ethan Hunt (Tom Cruise) and his team at their base camp on a sheep station surveying Nyah's arrival by satellite. As the speedboat turns in toward Ambrose's exquisite angular home which sits perched on Bradleys Head, the camera cuts back and forth between the ill-fated former lovers, each shot getting longer and more sun drenched than the last. Nyah steps off the boat and slowly, lithely makes her way along the long jetty. Ambrose meets her at the steps of the house. They embrace and kiss by dappled sunset as Ethan looks on aghast by satellite surveillance. The exaggerated tone of the scene serves as an example of the entire film. Though the jetty Nyah walks along has been jutting out into Sydney Harbour since the mid-1800s, Ambrose's house was made for the film. No building actually sits at that location. The set, made almost entirely from polystyrene, is just a mask beneath which lies an iconic and historic piece of the harbour. The film is full of characters wearing other people's faces over their own and it would seem that this historic piece of Sydney needed a mask pulled over it as well. **•❖Daniel Eisenberg**

Photo © Chloe Teh (Panoramio)

Directed by John Woo
Scene description: Nyah arrives at Ambrose's house
Timecode for scene: 0:34:21 – 0:36:40

LOOKING FOR ALIBRANDI (2000)

Sydney Opera House, Bennelong Point, NSW 2000

THE OPERA HOUSE, situated on Bennelong Point in Sydney Harbour, forms one of the city's most iconic silhouettes. Designed by Danish architect Jørn Utzon and opened in October 1973 as a performing arts centre, this landmark of expressionist design forms a cluster of performance venues that are housed by striking concrete shells. Generally depicted on film in a 'postcard'-style shot of Sydney Harbour, in *Looking for Alibrandi* we are provided with a rare look inside one of the arts venues as 17-year-old Josephine 'Josie' Alibrandi (Pia Miranda) delivers a speech at a 'Have Your Say Day'. The Opera House becomes a space that is decidedly more 'lived in'; Australian life as seen from the inside, as opposed to from an outsider's perspective. Even though the audience of peers to which Josie delivers her speech is from a range of different ethnic backgrounds, a microcosm of multicultural urban Australia, it is clear that Josie does not feel like she is part of the Australian cultural heritage that a setting such as the Opera House represents. As she looks up at love interest John Barton (Matthew Newton) shaking the hand of the Premier of New South Wales, with heavy sarcasm Josie retorts to a friend, 'Yeah – I could just imagine them letting a wog be Prime Minister.' Apparent is a deep struggle with her traditional Italian heritage and sense of cultural identity, one that is foregrounded when played out against the symbolic backdrop of the setting. •➧***Erin Pearson***

Directed by Kate Woods
Scene description: Josie Alibrandi delivers a speech at a 'Have Your Say Day'
Timecode for scene: 0:21:45 – 0:25:02

LANTANA (2001)

Darling Street, Balmain, NSW

LANTANA, Ray Lawrence's circling treatise on interconnection, dwells in the fleeting moments. Enamoured with actions and consequences, it shows how one simple choice or thought – or careless lack thereof – can have lasting repercussions, in an intricate tapestry of the thematic touch points of love, lust, loyalty and loss. All over Sydney and its outskirts, its ensemble of characters drift in and out of each other's orbits, weaving a web both fragile and complex. Couples collapse, neighbours collide and colleagues careen. Though the film is concerted in its efforts to ensure the group remains intertwined, one of the central cohorts – American psychologist Dr Valerie Somers (Barbara Hershey) – stands out amongst the rest, a literal outsider in an insular locale. Valerie is married to the distanced John (Geoffrey Rush), and a psychologist to the unhappily married Sonja Zat (Kerry Armstrong), as well as bearing her own weighty demons of grief. She experiences one of the feature's many instances of ordinary yet notable connections on the busy streets of Balmain, stumbling into Pete O'May (Glenn Robbins) – the estranged husband of Jane (Rachael Blake), who is having an affair with Sonja's husband Leon (Anthony LaPaglia) – and accusing him of saying something to her as they pass. Darling Street could be any other, indistinguishable in its features, but its bustling vibe, filled with people, affords the short scene the appropriate context. Their altercation is small and swift, but played out in public, influencing others and open to witnesses as if it was on stage. ⟿*Sarah Ward*

Photo © Sam McCosh

Directed by Ray Lawrence
Scene description: *Valerie stumbles into Pete on Darling Street*
Timecode for scene: *0:42:35 – 0:43:05*

GARAGE DAYS (2002)

LOCATION *The Domain, NSW 2000*

AMBITIOUSLY, A LENGTHY SCENE of a fictional Sydney-based rock band actually playing live at Homebake 2001 formed the crux of *Garage Days*'s production. As one of Australia's most prominent and popular music festivals, held until 2012 on the 34 hectares of open space that forms Sydney's historic Domain, there was perhaps no better symbol of success for a struggling garage band. Advertising tagged that year's festival as 'Homebake with a Hollywood Touch' far ahead of time, so that the filming and sudden appearance of well-known Australian actors onstage would not surprise the audience. Despite this and nearly two years of planning, it was bad weather that nearly scuppered the shoot. Perhaps also because of this, director Alex Proyas and cinematographer Simon Duggan constructed a sequence that captures an authentic sense of tension, excitement and fear. This can certainly be related to the experiences of the cast and crew, having to undertake a one-time-only shoot in front of thousands of festivalgoers amped up for their five minutes of fame. However, the location choice paid off, with the scene forming the film's most climactic moment, with shots panning over the immense crowd suggesting that the band have finally overcome the odds and 'made it'. Although, as lead singer Freddy (Kick Gurry) describes, their 'suckage factor was enormous', this uplifting scene captures the elation of a band having their moment in the spotlight •❖*Erin Pearson*

Photo © J Bar (wikimedia commons)

Directed by Alex Proyas
Scene description: A garage band gets the opportunity to play to a large crowd at Homebake Festival
Timecode for scene: 1:27:58 – 1:34:50

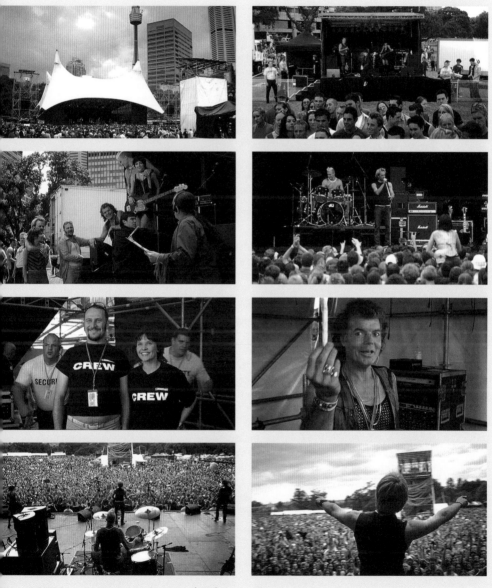

LITTLE FISH (2005)

LOCATION *44 Park Road, Cabramatta, NSW 2166*

SET IN CABRAMATTA, *Little Fish* is the story of recovering junkie Tracy Heart (Cate Blanchett) living what screenwriter, Jacqueline Perske, has described as 'the life Shakespearean'. A neighbourhood known for its immigrant Vietnamese population and notorious for its associations with the illegal drugs trade, Rowan Woods's crime drama very cleverly presents it in a much more positive, multicultural light and provides an accompanying mixed-race romantic relationship within the film. But no issues are made out of these representations. It is simply a modern portrait of Australia's increased ethnic diversity. Tracy's dream is to own the video shop where she works. But it's more than just a place of employment and a business opportunity – the place represents a foundation on which to rebuild her life after the devastation wrought by heroin addiction. Tracy, however, finds it tough going to get a bank loan and is prone to telling lies in order to conceal the fact she has hit a roadblock. During one sequence in the video shop, in actuality a set-dressed location, 'Tracy blatantly fibs to the business's current owner about the bank granting the application that would allow her to expand things and offer security for the future. The shop is also where Tracy takes unwelcome possession of drugs – hidden in little blue plastic fish, inside her brother's trainers. The temptation to slip back into the old habit is always present, but she is determined to live a good life, even as events conspire against her. •*Martyn Conterio*

Directed by Rowan Woods
Scene description: Tracy's Lies
Timecode for scene: 0:12:36 – 0:14:42

UBU FILMS

Text by
LISA
FRENCH

Sydney's Underground Radical Culture 1965–72

SYDNEY IS MOST WELL KNOWN
internationally for its spectacular harbour, opera
house and stunning Northern Beaches. But
the history of the city includes an avant-garde
underbelly. In 1965 Sydney was a fertile breeding
ground for counter-cultural, underground
cinema. and one of Australia's first avant-garde
independent film-making, distribution and
exhibition groups, 'Ubu', was established. The
name, from Alfred Jarry's 1896 subversive play,
Ubu Roi, signposted their revolutionary aims.
Ubu's members experimented with film form and
pushed the boundaries of cultural conventions.
They screened their own work and that of
international and local avant-garde film-makers
like Bruce Connor, Norman McLaren, Paul
Winkler and Dusan Marek. They lobbied against
censorship and built a creative community.
Numerous members later became important to
the revival of the Australian feature film industry
in the 1970s, including Bruce Beresford, Yoram
Gross, Phillip Noyce and Peter Weir.

According to Peter Mudie in his 1997 book on

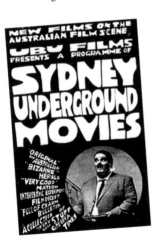

the group: *Ubu Films: Sydney Underground Movies
1965–1970* (p. 26), Ubu formed in Paddington at
the home of Albie Thoms. John Clark offered to
share his Tula Press offices in Redfern as the first
office from August 1965 (other founders were
David Perry and Aggy Read). Paddington became
an important location for Ubu's activities, and
today it is still a hub of art galleries and the well-
known Paddington market. Albie Thoms's 1966
Rita and Dundi (available on YouTube) features a
vista of Paddington's famous cast-iron balconied
terrace houses. The film evolved through Ubu's
association with the Sydney 'Push', a libertarian
group that rejected conventional morality. Formed
in the 1940s, Push members included John Flaus,
Germaine Greer and Frank Moorehouse. *Rita
and Dundi*, a portrait of two actual young women
associated with the 'Push', depicted their lifestyles
in a shared house in Paddington. Filmed against
a background of student life, the 'mod' fashions
of the time and a milieu of young artists, the film
was banned for nudity and was refused export
(although a defiant Ubu illegally exported and
screened it).

Ubu's first film screening in Goodhope Street
Paddington was less than two weeks after the
group was established. They showed a mix of
overseas and local films, including a film that
had earlier been banned because it contained a
representation of faeces falling from the sky (…
it droppeth as the gentle rain [1963]). Shot at
Sydney's historic Rocks (the colony founding place
at Sydney Cove, under the Harbour Bridge), and
at an upper-north-shore house in bushland St
Ives, it was a collaboration between two Sydney
University film students, Albie Thoms and Bruce
Beresford. The film …*it droppeth as the gentle rain*
could only be seen at underground screenings
usually held in private homes. Therefore, it was an
ideal film to begin Ubu's journey, which from its

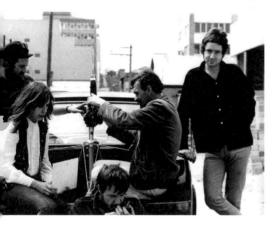

deeply conservative Menzies era and the group's history offers insight into the social and political transitions of this period. Ubu hosted 'happenings', which variously took the form of group film-making, performance poetry or lightshows.

An example of a happening is *The Film* (1966), attributed to Thoms, but which was a collective effort. Gary Shead had been offered an out-dated batch of film stock that he shared with members, who used a variety of lenses and film speeds to film each other on four cameras simultaneously. Those attending joined in, improvising dramatic actions. The result is a piece that is not so much of interest as a film, but as a document of a 'happening'.

Many of the films were made on the streets of Sydney, including David Perry's *Harbour* (1967), an urban landscape where a woman with a red umbrella walks through Sydney Harbour's docklands. Another was Albie Thoms's *Bolero* (1967), set to Maurice Ravel's well-known orchestral score. Shot in Walker Street, North Sydney, this minimalist film depicts real-time through a single shot tracking up the street to a woman's eye in close-up. Gradual changes taking place in the film-frame heighten observation of the urban environment and the capturing of it. There is also a large body of films that are handmade and abstract (e.g. David Perry's 1966 film *Puncture* or Albie Thom's 1966 film *Bluto*). These do not capture the vistas of Sydney, but are kinetic visual feasts demonstrating experimental innovation and interest in film form. Their formalist concerns expressed though minimalism, kinaesthetic art and abstract expressionism were shared by the broader art world in 1960s Australia.

Between 1965 and 1972 Ubu formed a vibrant community. Members of the group went on to celebrate Sydney as the Australian feature industry developed, including Bruce Beresford with his 1981 film *Puberty Blues* (featuring the beaches south of Botany Bay); Albie Thoms's 1980 film *Palm Beach* (a surfing film set on Sydney's most famous Northern Beach); and Phillip Noyce's 1982 noir thriller *Heatwave* (which fictionalized the disappearance of anti-development campaigner Juanita Neilson). The fact that many Ubu members participated in the revival of Australian cinema in the 1970s demonstrates the importance of a vibrant screen culture to energizing the production sector. As a counter-cultural movement, Ubu played an important part in developing Australian national cinema, and the role Sydney came to play in it. ✢

inception involved ongoing battles with censors. The film had been scheduled to premier at the Sydney University's Union Theatre on 28 March 1963 but the ban caused the theatre to refuse to show it for fear of losing their licence. So instead, according to publicity material produced by Thoms, he read the injunction to the audience, presenting it as having been written by 'a master' of the Theatre of the Absurd.

Despite this misadventure, the Union Theatre and the University, which had been an important location for film culture since the 1950s, was to have a long association with Ubu. Mudie's 1997 book recalls various collaborations, including Ubu being hired by Matt Carroll (who later produced films such as Bruce Beresford's *Breaker Morant* [1980] and *Storm Boy* [Henri Safran, 1976]) to screen films at the Architecture Ball in 1966. They also produced a 'lightshow' for the floating ballroom at the 1968 COMMEM ball held at Luna Park, and these popular shows provided Ubu with reliable income for their activities. The group produced a newsletter (*Ubu News*) and much of its content was devoted to attacking the censors with headlines like 'Defeat Censorship' (June 1969). Issue 12 reported that Phillip Noyce was charged for hawking it, receiving a twelve-month good behaviour bond for selling an 'indecent item' on the street. This took place in the final period of the

The fact that many Ubu members participated in the revival of Australian cinema in the 1970s demonstrates the importance of a vibrant screen culture to energizing the production sector.

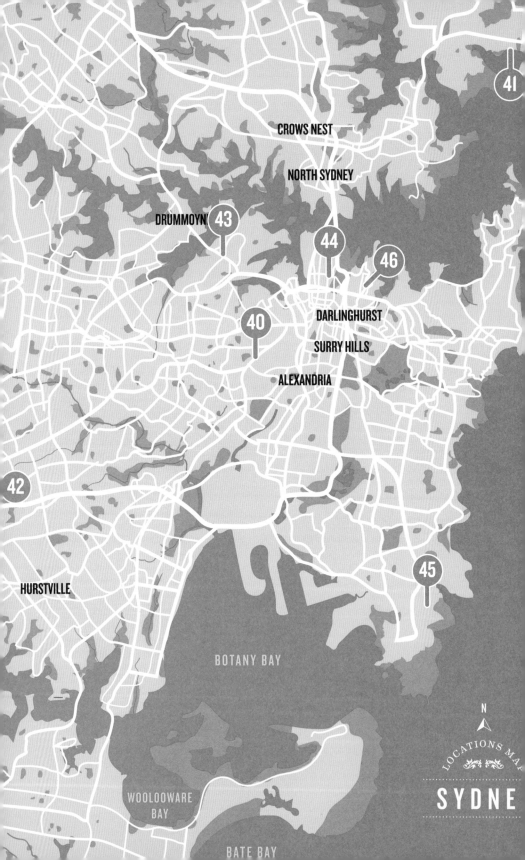

CROWS NEST

NORTH SYDNEY

DRUMMOYN **43**

44

46

DARLINGHURST

40

SURRY HILLS

ALEXANDRIA

42

41

45

HURSTVILLE

BOTANY BAY

N

WOOLOOWARE
BAY

LOCATIONS MAP

SYDNE

BATE BAY

SYDNEY LOCATIONS

SCENES 40-46

maps are only to be taken as approximates

CANDY (2006)

LOCATION *West End Dealers Loan Office, 193 King Street, Newtown, NSW 2042*

ARMFIELD'S FILM OF LOVE, lust and addiction is broken into three acts entitled 'Heaven', 'Earth' and 'Hell', and one crucial scene acts as the tipping point that begins the young lovers' accelerated fall. Candy (Abbie Cornish) and Dan (Heath Ledger) are passionately in love and aggressively addicted to heroin. Though the film opens with Candy almost overdosing, 'Heaven' follows them as they experience the world through the filter of heroin, engaging their heightened senses physically and emotionally. The cost of their habit starts to creep in: they borrow money from friends and, in this scene, try to pawn family jewellery. However, when Candy returns to the car, ducking through King Street traffic having got only 25 dollars for a ring, the situation shifts irrevocably. With a steely calm Candy tells Dan 'she will be back', that the pawnbroker had said 'maybe he can work something out'. She walks back across the street with purpose, and as Candy enters the battered yellow storefront the owner shuts the door, turning the sign to closed. The camera slowly circles Dan, a tight close-up showing the vacant, accepting expression on his face. The soundtrack becomes more disjointed; traffic sounds are oddly accented until the car door opens, breaking his trance. The words 'body piercing' glow garishly behind Candy. 'Yes I fucked him,' she says flatly, 'for fifty bucks... he stank.' Dan mumbles a pathetic 'I'm sorry'. This run-down pawn store acts as the pivot in the lovers' descent. With business-like efficiency, the destruction that can and will be wrought by their addiction begins. **❧Daniel Eisenberg**

Photo © Andrew Buckle

Directed by Neil Armfield
Scene description: Candy visits the pawnbrokers
Timecode for scene: 0:16:58 – 0:19:34

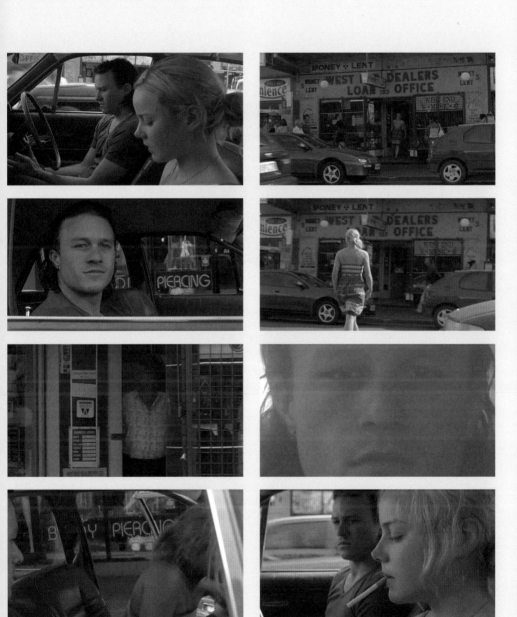

THE BET (2007)

LOCATION *Manly Sea Life Sanctuary W Esplanade, Manly NSW 2095*

FOR A MOVIE SET IN SYDNEY, the expression 'swimming with sharks' might well mean a literal dip in one of the bays or beaches dotted around the city. *The Bet*, however, uses the term as a sledgehammer metaphor. A Faustian drama which sees two high-flying friends, Gus (Aden Young) and Will (Matthew Newton), one a Cambridge-educated banker and the other a self-made man and stockbroker, in a moment of braggadocio, make a wager: they've got 90 days to earn the largest amount of dough, through various deals and trading. Whoever rakes in the most is rewarded with $100,000 dollars. Will takes corporate lawyer girlfriend, Tory (Sibylla Budd), for a trip to OceanWorld (today known as Manly Sea Life Sanctuary). The cocksure lad clearly identifies with the sharks – apex predators in the food chain – when really he's more like little Nemo from the 2003 Pixar classic. It might play as a romantic scene between new lovers finding out more about each other, but lurking there – like those menacing denizens of the deep floating above them – is the film's major theme: self-deception. Will thinks he can swim with the sharks and not be eaten alive. *The Bet* is set in exclusive haunts: posh golf courses and polo clubs, trendy bars and expensive apartments with spectacular views of Sydney Harbour, and furnished with a decor dripping with affluence. In an early scene, in fact, the very first scene in which the bet is made, Mephistophelean Gus sums up his personal view of Sydney: 'You know the problem with this city? It's just too good-looking.'
∙▹ Martyn Conterio

Photo © Alan Farlow (Panoramio)

Directed by Mark Lee
Scene description: Will and Tory at OceanWorld
Timecode for scene: 0:14:54 – 0:16:11

THE BLACK BALLOON (2008)

LOCATION *36 Infantry Parade, Holsworthy NSW 2173*

ELISSA DOWN'S SEMI-AUTOBIOGRAPHICAL dramedy, *The Black Balloon*, unfolds entirely within the suburb of Holsworthy. It is at the gates of Holsworthy High School that Thomas Mollison (Rhys Wakefield) is forced to defend brother Charlie (Luke Ford) from a gang of bullies, as well as suffer an intense degree of embarrassment in front of an overexcited, rubbernecking crowd of fellow pupils and teachers. Thomas's concern for Charlie's well-being – he suffers from severe autism and ADD – is countered by an increasingly conflicted emotional resentment towards such a familial duty. Thomas is a teenager struggling with the typical trials and tribulations. Often forced to babysit and literally chase the older sibling around, he'd much rather be spending time with Jackie (Gemma Ward), a local girl he fancies and who appears unperturbed by Charlie's occasionally 'bad' behaviour. Downs's film depicts the Holsworthy neighbourhood as (while possessing a uniform blandness of bungalows and modern homes) a colourful and sunny place, capturing the heat of long summer days and often framed in pretty, eye-catching compositions. The scene at the school gates works as a dramatic culmination of the attitudes and casual cruelty experienced outside the safe confines of the Mollison family home. It is made very clear that the locals look upon Charlie as a freak and nuisance. Thomas, therefore, feels freakish by association. The socially unacceptable word 'spastic' is heard a few times, including during the first line of dialogue uttered, and often as a taunt. It serves as a reminder, too, of that word's blanket usage in the 1980s and 1990s.
➺Martyn Conterio

Photo © Google street view

Directed by Elissa Down
Scene description: Bullied at the School Gate
Timecode for scene: 0:01:00 – 0:01:06

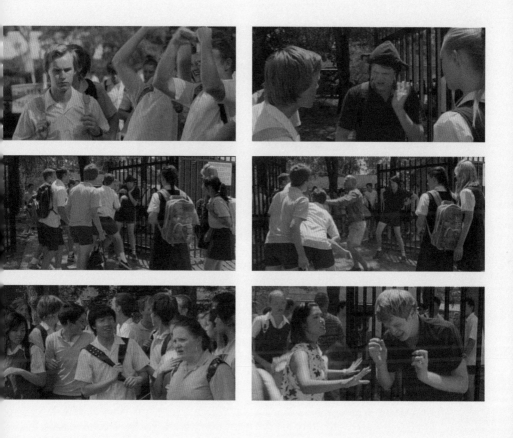

THREE BLIND MICE (2008)

LOCATION *Lipari Pizza, 701 Darling Street, Rozelle NSW 2039*

FILMED ON THE HOOF AROUND SYDNEY, with no official shooting permits, actor and director Matthew Newton's *Three Blind Mice* sees three naval officers out on the town the night before they once again ship out to Iraq. Newton's cocksure Harry is determined to party, troubled Sam (Ewen Leslie) is preparing to go AWOL and level-headed Dean (Toby Schmitz) just wants to meet up, and reconnect, with his fiancée. Guilty secrets, masculine crises, the bonds of friendship and moral responsibility come to the fore as the traumatic incident at sea that has so damaged Sam has implications that all three must face up to. The winner of the FIPRESCI prize at the 2008 Times BFI London Film Festival, *Three Blind Mice* features a veritable who's who of Australian actors, including Jackie Weaver and Charles 'Bud' Tingwell. The faces may be familiar, but the film largely eschews the usual landmark locations you'd expect to see in a Sydney-set film. Nondescript hotel rooms, bars and restaurants are the environments the officers frequent during the night, one of these being the family-run Lipari Pizza at 701 Darling Street in Rozelle, now relocated to 681. It is here that Sam, egged on by ladies man Harry, strikes up a conversation with waitress Emma (Gracie Otto). The relaxed, cosy establishment, one that has served the area since the early 1990s, is a canny setting for a scene in which a serving officer makes a connection with a member of the general population, and briefly forgets about his private torments. ➻ *Neil Mitchell*

Photo © Google street view

Directed by Matthew Newton
Scene description: 'You're the most beautiful girl I've ever seen'
Timecode for scene: 0:12:22 – 0:15:30

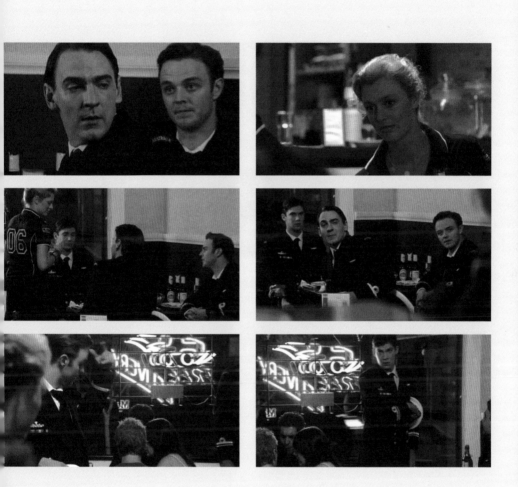

THE TUNNEL (2011)

LOCATION *St James Station, NSW 2000*

FOUND-FOOTAGE HORROR FILM *The Tunnel* follows journalist Natasha Warner (Bel Deliá) and her film crew as they venture into the mysterious tunnels underneath St James Station in Hyde Park. Rumours that homeless people have disappeared there, despite staunch government denials that anything unusual is occurring, inspire Natasha to crack the story at any cost. Her desperate attempt to save a dwindling career in television current affairs leads Natasha and her colleagues into a battle for survival, as they discover a shocking truth and are stalked by a terrifying mutant. Issues of legitimacy mark the crews attempts to access the tunnels. Initially they seek access via St James Station, but without the correct paperwork they are turned away. Aware that the tunnel story is her last shot, Natasha lies to her already suspicious crew and convinces them that breaking into the tunnels through a hidden entrance is a necessary (although not ideal) course of action. This choice of location acts as a powerful symbol for the heated debates that have marked the so-called Australian history wars concerning the colonial origins of Australia and the consequent official treatment of Indigenous people. This division is mirrored in *The Tunnel* by Natasha and her crew's discovery of what lies literally buried underneath Hyde Park, a space renowned for its history as a colonial playground. *The Tunnel's* utilization of this subterranean space provides it with poignant metaphorical terrain to reflect on the broader tensions that have marked Australia's sociopolitical history.
➻ Alexandra Heller-Nicholas

Directed by Carlo Ledesma
Scene description: Accessing the tunnels
Timecode for scene: 0:23:12 – 0:26:58

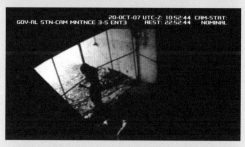

33 POSTCARDS (2011)

LOCATION *Long Bay Correctional Facility, 1300 Anzac Parade, Malabar, NSW 2036*

WHEN CHINESE ORPHAN Mei Mei (Zhu Lin), visiting Sydney with her orphanage's choir, gets to meet her Australian sponsor Dean (Guy Pearce) for the first time, you'd expect it to be a joyous occasion. For Mei Mei, however, it's anything but, as the truth about her benefactor's status leaves her disappointed and confused. Rather than being the contented family man described in the many postcards mild-mannered Dean has sent to Mei Mei, he's actually incarcerated for manslaughter. Thinking that Dean works at Long Bay Correctional Facility, Mei Mei is, unsurprisingly, thrown out by the revelation that he is in fact a prisoner of the establishment. *33 Postcards*, the first co-production between China and New South Wales, is a low-key human drama about trust, emotional connections, naivety and sacrifice. Misfits in their respective societies, Mei Mei and Dean, soon to be released on parole, are both looking for something in each other; security in the orphan's case and redemption in the prisoner's. The prison scenes were shot on location at Long Bay, a complex that opened in 1909 and holds maximum and minimum security prisoners of both genders in three separate divisions. Situated 14 kilometres south of Sydney's CBD, Long Bay started out as a women's prison for its first five years in operation and later included the much criticized supermax prison block, Katingal. In Pauline Chan's film, Long Bay becomes, fittingly, the place where cold, hard reality hits home for Mei Mei.
➼ Neil Mitchell

Directed by Pauline Chan
Scene description: Mei Mei meets Dean for the first time
Timecode for scene: 0:12:00 – 0:17:45

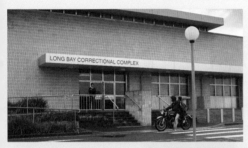 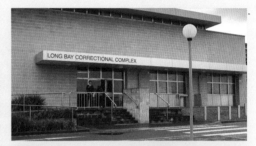

 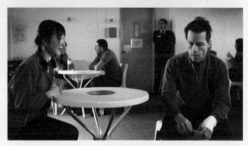

X: NIGHT OF VENGEANCE (2011)

LOCATION *Darlinghurst Road, Kings Cross, NSW*

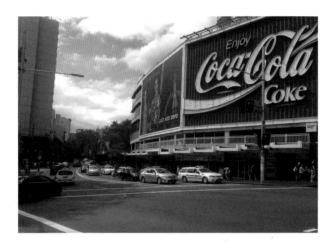

EARLY IN JON HEWITT'S *X: Night of Vengeance*, two wayward lives come together in a pointed scene that opens with a shot of two neighbouring establishments on Darlinghurst Road, the central strip of Sydney's vice district Kings Cross. The first is famous nude club Show Girls – and yet, even though the film is concerned primarily with prostitution, Hewitt will not take us to a strip club till later, preferring here to focus on a fast-food store which, with its 'Open 24 Hours' sign and its sale of fast, cheap gratification, makes for a provocative consumerist analogue to the sex industry. In a crowd of people engaged in eating, it is at first difficult to pick out young runaway Shay (Hanna Morgan Lawrence). With the money she has just earned administering a handjob, Shay is also purchasing food – fries and a shake – when she is approached by the even younger Cindy (Freya Tingley) who deftly cadges from her a soft serve and small change, all the while dispensing advice on how to keep money safe from vigilant predators (like herself). As they cross the road, the more experienced Cindy places a solicitous, guiding hand on Shay's arm. We sense the two girls' mix of needy *naïveté* and premature wisdom – but most of all, in a very busy street-shot handheld as though from a punter's point of view, we notice how Shay and Cindy themselves risk being both overwhelmed and consumed by the passing traffic. **Anton Bitel**

Photo © Andrew Buckle

Directed by Jon Hewitt
Scene description: Shay meets Cindy on Darlinghurst Road
Timecode for scene: 0:14:59 – 0:17:25

GO FURTHER

Recommended reading, useful websites and film availability

BOOKS

Australian Screen Classics: Puberty Blues
by Nell Schofield
(Currency Press, 2004)

Australian Screen Classics: The Boys
by Andrew Frost
(Currency Press, 2010)

Australian Cinema 1970–1985
by Brian McFarlane
(Secker & Warburg, 1987)

Australian Cinema after Mabo
by Felicity Collins and Therese Davis
(Cambridge University Press, 2004)

**Australian Cinema:
The First 80 Years**
by Brian Adams and Graham Shirley
(Currency Press, 1983)

Australian National Cinema
by Tom O'Regan
(Routledge, 1996)

Diasporas of Australian Cinema
ed. by Catherine Simpson, Renata
Murawska and Anthony Lambert
(Intellect, 2009)

**Directory of World Cinema:
Australia and New Zealand**
ed. by Ben Goldsmith and Geoff Lealand
(Intellect, 2010)

**UBU Films: Sydney Underground Movies
1965–1970**
by Peter Mudie
(UNSW Press, 1997)

World Film Locations: Melbourne
ed. by Neil Mitchell
(Intellect, 2012)

FILMS

88.9 Radio Redfern
Sharon Bell and Geoff Burton, dirs. (1988)
Observational documentary about Sydney's fi
community Aboriginal radio station.

Autopsy on a Dream
John Weiley, dir. (2013)
Documentary recounting the turbulent origin
of the Sydney Opera House.

Life in Australia: Sydney
Joe Scully, dir. (1966)
A look at life in the city in the 1960s.

Indonesia Calling
Joris Ivens, dir. (1946)
A documentary set on the wharves of Sydney
about local seamen and waterside workers.

ONLINE

Australian Screen Online
aso.gov.au/Australia's audio-visual heritage webs

Filmsite
http://filmsite.com.au/
Film and photographic locations in Sydney.

National Film & Sound Archive
http://www.nfsa.gov.au/

Senses of Cinema
http://www.sensesofcinema.com/
Melbourne based online film journal.

UBU Films
www.milesago.com/visual/ubu
Webpage dedicated to UBU.

Sydney Film Festival
www.sff.org.au/
Sydney Film Festival website.

CONTRIBUTORS

Editor and contributing writer biographies

EDITOR

NEIL MITCHELL is a freelance writer and editor based in Brighton, UK. He is the film co-ordinator for the Australia and New Zealand Festival of Literature & Arts and the editor *Directory of World Cinema: Britain 2* and the London and Melbourne editions of Intellect's World Film Locations series. His monograph on Brian De Palma's *Carrie* was published in 2013 as part of Auteur Publishing's Devil's Advocates series.

CONTRIBUTORS

An Australian in the UK, **ANTON BITEL** compensates for a general sense of disgruntlement by haunting darkened screening rooms watching others' joys and sorrows. A member of the Online Film Critics Society and the London Film Critics' Circle, he regularly freelances for *Sight & Sound*, *Little White Lies* and *Film4.com*.

GEMMA BLACKWOOD lives in Darwin, and is Lecturer in Communications in the School of Creative Arts and Humanities at Charles Darwin University. She holds a PhD in Film Studies and Cultural Studies from the University of Melbourne and is currently finishing a book on contemporary film tourism. Her new research examines the representation of the Australian outback in cinema.

DEAN BRANDUM is a PhD candidate at Deakin University where he has taught Australian cinema history. He maintains the website *technicolouryawn. com* and although he lives in Melbourne he reckons Sydney is the best place to recover from a hangover.

MARTYN CONTERIO is a film critic, features writer, editor and author of a monograph on Mario Bava's *Black Sunday*. He has written for *Little White Lies*, *Film4.com*, *Grolsch Film Works*, *Total Film*, *Film Int.*, *The Guardian* and *Scene 360*.

ADRIAN DANKS is Director of Higher Degree Research in the School of Media and Communication, RMIT University. He is currently completing several projects including a book examining 'international' feature film production in Australia during the period 1945–75 (*Australian International Pictures*, with Con Verevis, to be published by Edinburgh University Press), and an edited companion to the work of Robert Altman (Wiley/Blackwell).

DANIEL EISENBERG is currently Curator of Film and Sound at the Australian War Memorial and is also completing his PhD at the Australian National University on 'Australian Westerns'. He is also a trained film archivist, conservator and projectionist, a sporadic lecturer in Australian film, an occasional film reviewer and insatiable fan of all things cinema.

LISA FRENCH is Deputy Dean, School of Media and Communication, RMIT University. She co-wrote the books *Shining a Light: 50 Years of the AFI* and *Womenvision: Women and the Moving Image in Australia*. Her professional history comprises producing films and screen-culture posts, including Director of the St Kilda Film Festival.

ALEXANDRA HELLER-NICHOLAS is an Adjunct Research Fellow at the Institute of Social Research at Swinburne University of Technology, Melbourne, Australia. She is the author of *Rape-Revenge Films: A Critical Study* (2011) and *Found Footage Horror Films: Fear and the Appearance of Reality* (2014).

TINA KAUFMAN is a writer on film, media and communication issues. She edited *Filmnews* for seventeen years and since then has been contributing editor for *Metro* and regularly written for the online publication *Screen Hub*, and the arts ➜

CONTRIBUTORS

Editor and contributing writer biographies (continued)

bi-monthly *Real Time*. She is the author of *Wake in Fright* for Currency Press's Australian Screen Classics series. She is an Honorary Life Member of the Sydney Film Festival and of the Film Critics' Circle of Australia.

JANE MILLS, PhD teaches film at UNSW, Australia. She's written and broadcast on cinema, censorship, feminism, and human rights. Her current research involves screen literacy, cosmopolitanism, geocriticism, and sojourner cinema. Jane is Series Editor of *Australian Screen Classics*. Her recent books include *Jedda* (2012) and *Loving and Hating Hollywood: Reframing Global and Local Cinema* (2009).

WHITNEY MONAGHAN has a PhD from Monash University in Melbourne, Australia. Her research focuses on the representation of queer girls in screen media and her work has appeared in the journals *Jump Cut*, *Colloquy* and *Screen Machine*. She is also the editor of online film magazine *Peephole Journal* (www.peepholejournal. tv) and can be found tweeting most days @jatneywhitmo.

A PhD candidate at King's College London, **STEPHEN MORGAN** explores national (and transnational) cinema and identity, with a particular interest in the intersection between British and Australian cinema and wider British–Australian sociocultural relations. He has published work in *Studies in Australasian Cinema*, *Reviews in Australian Studies* and the BFI/ Palgrave edited collection *Ealing Revisited*.

ERIN PEARSON is a writer, researcher and assistant editor for the online peer-reviewed journal *Intensities: The Journal of Cult Media*. She is currently undertaking an MPhil in Screen Media and Cultures at the University of Cambridge, and is working on a monograph based on Ben Wheatley's *Kill List* (2011).

JACK SARGEANT's work has been described as 'dangerously inspirational' by *Six Degrees* magazine, his numerous books include *Deathtripping: The Extreme Underground*, *Naked Lens: Beat Cinema*, *Cinema Contra Cinema* and *Suture*. He writes a regular column for *FilmInk*, and has written for *The Wire*, *Fortean Times*, *World Art* and many others. He is currently programme director for the Revelation Film Festival in Western Australia.

DEB VERHOEVEN is Professor and Chair of Media and Communication at Deakin University in Melbourne, Australia.

SARAH WARD is a Brisbane-based freelance film critic, arts writer and festival all-rounder. She writes film criticism and features for *artsHub*, is editor of *Trespass*, and is a regular contributor to *FilmInk*, *Metro* and *AtTheCinema*. Sarah also co-hosts the *SLiQ Flicks* film podcast, and guest hosts on ABC digital radio.

FILMOGRAPHY

All films mentioned or featured in this book